The College History Series

FISK UNIVERSITY

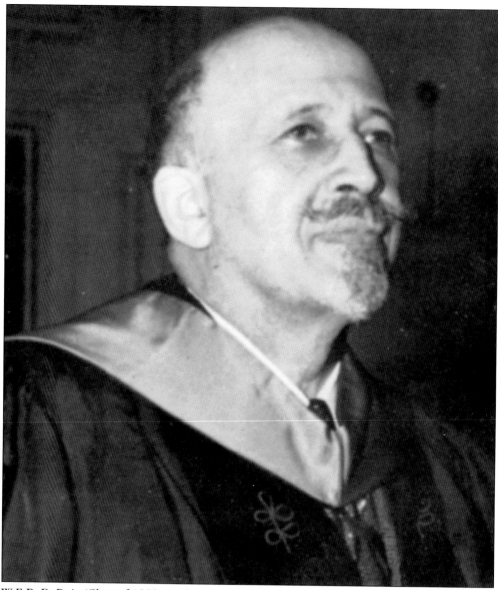

W.E.B. DuBois (Class of 1888), Fisk's most prominent son, was the first African American to receive a Ph.D. from America's oldest university—Harvard.

The College History Series

FISK UNIVERSITY

Rodney T. Cohen

ARCADIA
PUBLISHING

Published by Arcadia Publishing
Charleston, South Carolina

Printed in the United States of America

Library of Congress Catalog Card Number: 2001086351

For all general information contact Arcadia Publishing at:
Telephone 843-853-2070
Fax 843-853-0044
E-Mail sales@arcadiapublishing.com
For customer service and orders:
Toll-Free 1-888-313-2665

Visit us on the Internet at www.arcadiapublishing.com

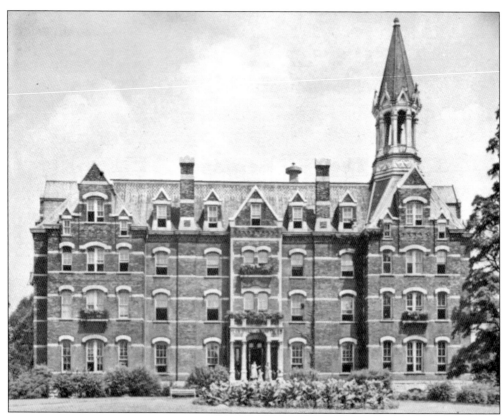

Constructed in 1873, Jubilee Hall was the first permanent building erected in America for the higher education of African Americans.

CONTENTS

INTRODUCTION

The history of African Americans in the United States since Emancipation has been one of struggle against economic, social, and educational adversity. Rising from a condition of dependency, African Americans were forced into a hostile environment to fend for themselves and produce institutions of survival. The record of achievement for African Americans is probably best seen in its institutions of higher learning. Practically without any material possessions or wealth, "black folk" were able to negotiate the development of their own colleges and universities. The raison d'etre for the founding of these colleges was solely due to the systematic and legal denial of African Americans from white colleges and universities. In response, shortly following the Civil War, many African Americans and some "benevolent" whites combined to establish a number of black colleges, including Atlanta University, Howard University, Talladega College, Biddle Institute, Hampton Institute, and Fisk University.

In addition to Fisk, Nashville has been home to three other historically black colleges and universities—Tennessee State University (TSU), Meharry Medical College, and Roger Williams University. TSU was founded as the Tennessee Agricultural and Industrial State Normal School in 1912. The school opened on part of the old Hadley plantation, approximately two miles west of Fisk. After several name changes and evolutionary developments, the university became Tennessee State University in 1969. Meharry was organized in 1876 as a medical department of Central Tennessee College, which later became Walden University. Later to be named after the family that contributed to its continuation, the medical department changed its name to the Meharry Medical College of Walden University in 1900. In 1915, Meharry became a separate institution. In 1931 it relocated from First Avenue to its present location in North Nashville, adjacent to Fisk. Roger Williams University, founded in 1864 as a "Bible School," once held the distinction of being the oldest college or university in Nashville. It later became the Nashville Normal and Theological Institute. In 1874, after being located on two different sites in North Nashville, the institute settled on a 30-acre plot on Hillsboro Road, a location now occupied by Peabody College of Vanderbilt University. In 1905 Roger William's major building, Centennial Hall, was destroyed by a fire of unknown causes. The school was forced to close. It reopened in 1909, and 25 years later merged with LeMoyne-Owen College in Memphis.

No different to the aforementioned colleges, Fisk's establishment and rise to prominence has been one of triumph and success. The founding of the university began as early as 1865 when John Ogden, Erastus Milo Cravath, and E.P. Smith of the American Missionary Association (AMA) developed a plan to establish a school for "The education and training of young men and women irrespective of color." Gen. Clinton B. Fisk of the Freedmen's

7

Bureau assisted them in this effort. He was key in the acquisition of quarters for the school. The new institution would open its doors for instruction on January 9, 1866, as the "Fisk School," in honor of Clinton B. Fisk. John Ogden served as the first principal of the Fisk School. It was not until the signing of the charter on August 12, 1867, that the Fisk School would become Fisk University.

In 1870, under the leadership of Adam K. Spence, plans were developed for the establishment of a strong academic program in addition to its relocation in North Nashville. Around this time, just five years after opening its doors, the university was in such a financial bind many expected its closure; however, with the help of a professor and a band of students the university was saved. In 1871, Professor George L. White and nine students left Nashville to perform concerts throughout the United States in hopes of securing enough funds for the salvation of the newly formed university. Initial responses included ridicule and scorn, mostly due to the fact that the group of five women and four men were not performing in the "slap-happy" tradition of the minstrel show. In response to the atmosphere of despair, Professor White decided to name the group "Jubilee Singers," in reference to the biblical year of Jubilee.

Soon afterwards, the attitudes of whites began to change, and suddenly the reactions of the crowds were replaced with brisk applause and standing ovations. The group's first official tour in the United States, which lasted three months and ended with a performance at the White House for President Ulysses S. Grant, not only brought national acclaim, it literally saved the university. Due to such recognition, subsequent tours both nationally and internationally would raise funds for the construction of the university's first permanent building, Jubilee Hall. Jubilee Hall was erected on the new location as the first permanent building the nation solely dedicated to the higher education of African Americans.

In the tradition of Jubilee Hall, Fisk has been an institution filled with "firsts." In 1930, it became the first historically black college or university (HBCU) to gain accreditation by the Southern Association of Colleges and Schools. Fisk was the first HBCU in 1933 and 1948 to be placed on the approved lists of the Association of American Universities and the American Association of University Women respectively. Fisk was also the first HBCU to receive a chapter of Phi Beta Kappa (1952) and a chapter of the Mortar Board.

In recent years, Fisk has received acclaim for sending more than half of its graduates to graduate and professional school in addition to being recognized by the National Science Foundation for producing more alumni who go on to earn the doctorate in the natural sciences than African Americans from any college or university—black or white.

It has been said that the mark of a great university is the degree to which its alumni have distinguished themselves, and in this case, Fisk has produced an outstanding record. Fiskites include such notables as W.E.B. DuBois, John Hope Franklin, Hazel O'Leary, Roland Hayes, Ronald Walters, Charles H. Wesley, Nikki Giovanni, Judith Jamison, C. Eric Lincoln, Wade McCree, Preston King, and David Levering Lewis.

In an attempt to bring to focus the great past of Fisk with its future successes, this book is a compilation of photographs and captions intended to inform while placing in the mind of the reader great "images of the past." In an era where excellence, sophistication, and dignity are often ignored and downplayed, Fisk University hopes to bring forth images, in many cases, now forgotten.

One

FISK AND THE EARLY YEARS

Fisk . . . compared favorably with white educational institutions of university grade . . . The New York Herald Tribune *claimed in 1947 that Fisk was "one of America's major institutions of learning. Its high academic standards and elevated cultural tone, as well as its seniority, have long justified its familiar appellation, 'the Negro Harvard.' "*

—A History of Fisk University

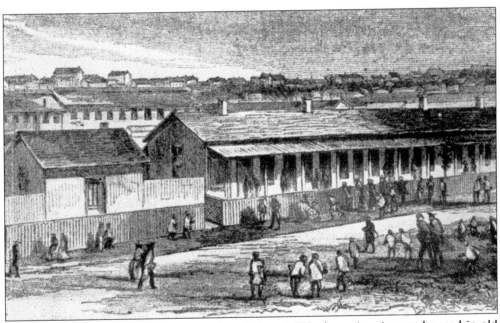

From 1866, when Fisk University was founded, to 1875, the university was housed in old Federal barracks from the Civil War. From this coarse frame structures lessons in reading and writing were taught to hundreds of ex-enslaved Africans in America. The American Missionary Association (AMA), which sponsored Fisk and other black colleges, bought the land at Fort Gillem where Fisk currently stands.

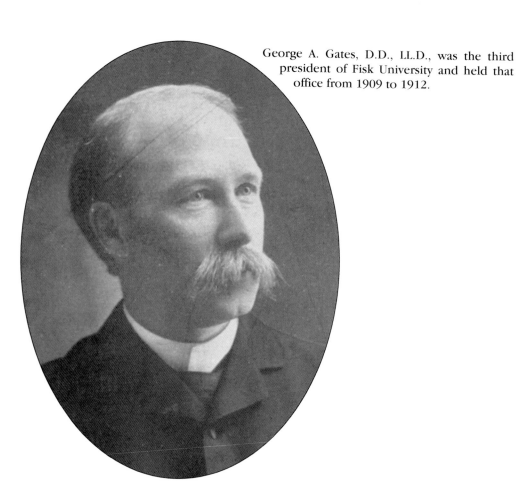

George A. Gates, D.D., LL.D., was the third president of Fisk University and held that office from 1909 to 1912.

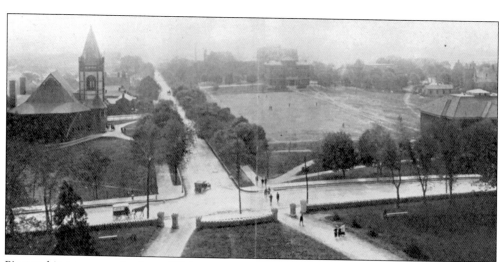

Pictured is a panoramic view of Fisk University in 1919.

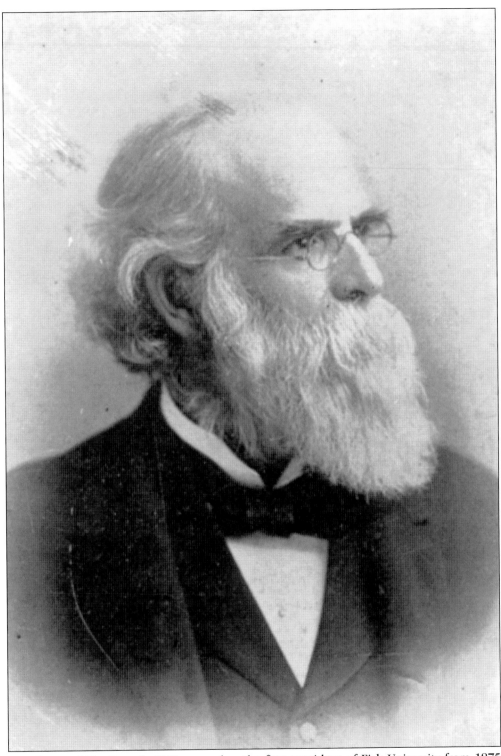

Rev. Erastus Milo Cravath, D.D., served as the first president of Fisk University from 1875 to 1900.

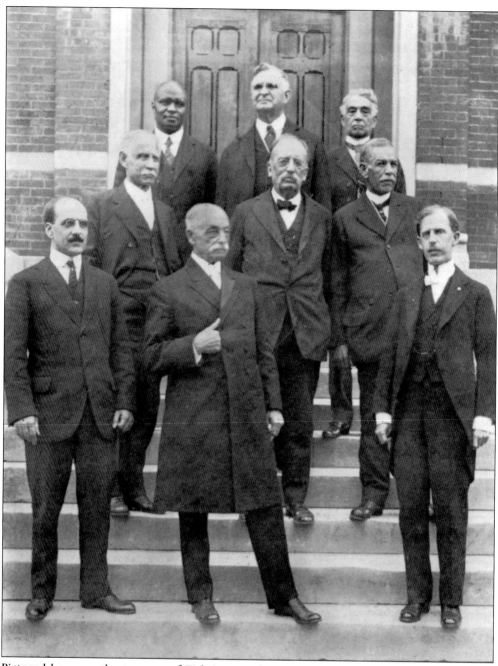

Pictured here are the trustees of Fisk in attendance at the inauguration of Fayette Avery McKenzie (first row, third from left) as president of university in November 1915. McKenzie served as president from 1915 to 1925.

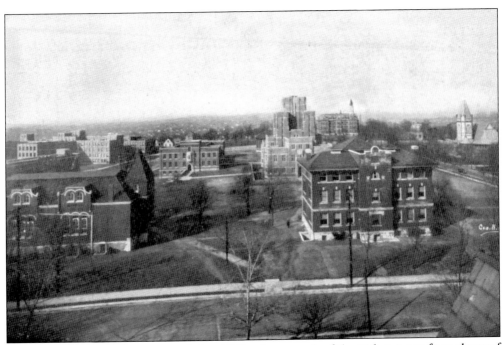

Photographer G.H. Anderson took this 1930s photograph of the Fisk campus from the roof of Livingstone Hall.

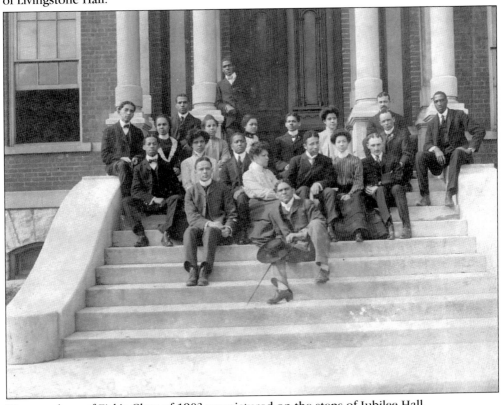

The members of Fisk's Class of 1903 are pictured on the steps of Jubilee Hall.

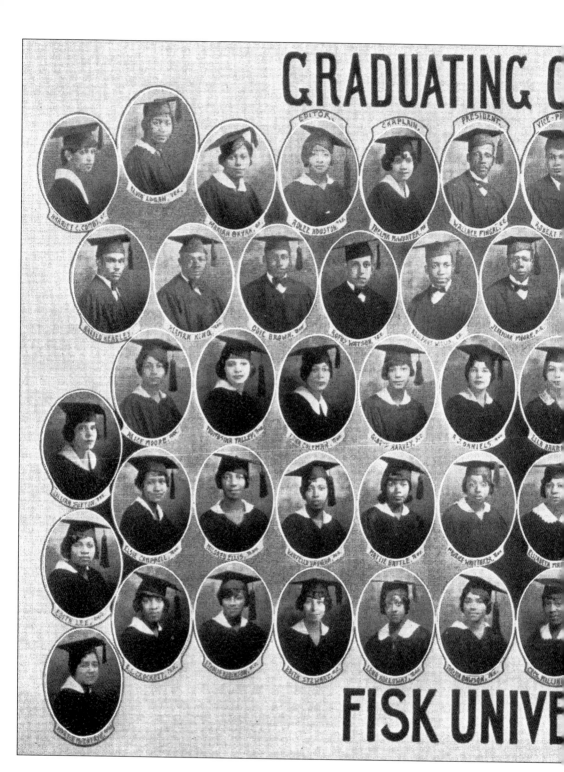

GRADUATING C

FISK UNIVE

14

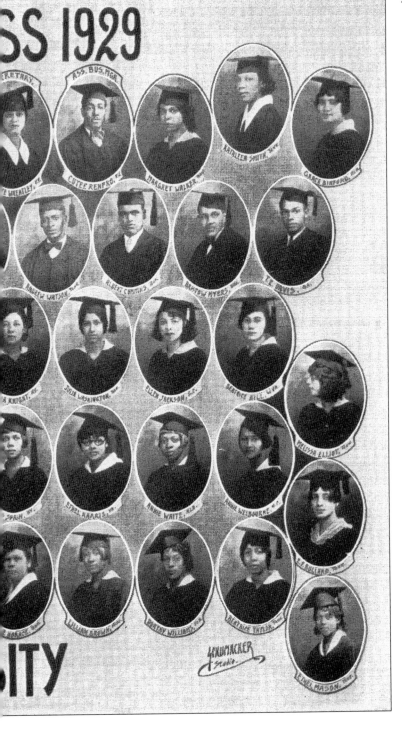

The Fisk Class of
1929 is shown here.

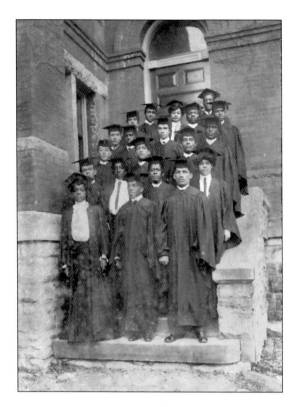

Pictured here is a photo of the Fisk University Class of 1904.

Bennett Hall was constructed in 1891 by a joint effort of $25,000 from the American Missionary Association and the Jubilee Singers. The building was named for Rev. Henry S. Bennett, who served as professor of theology and pastor at Fisk from 1867 to 1884. In addition to serving as a male dormitory, Bennett also served the university as home to the Fisk University School of Theology and Department of Sociology. Bennett Hall was eventually condemned and demolished.

Pictured is the 1929–1930 staff of the *Fisk Herald*. In 1883, the students of Fisk started the *Fisk Herald* as a publication to highlight student life at the university. By 1916, the publication was discontinued for lack of funds. In 1925, the publication experienced a rebirth, as "A Greater Fisk" became the slogan. The trustees of the university saw fit to provide funds for this rebirth of the newspaper, which would be known as the *Greater Fisk Herald*. The staff pictured above moved to link up a colorful past with an ambitious present by dropping the "Greater" from the title.

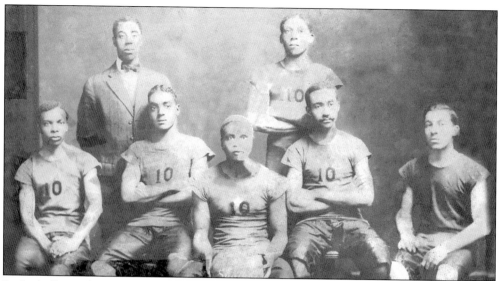

Basketball at Fisk was organized in 1903 and was originally started as an intramural sport for the purposes of boasting the moral and class spirit of the students. The first instructor or coach at Fisk would come from the local white YMCA where Fisk purchased its equipment. From 1903 until 1927, basketball at Fisk was solely intramural. After becoming intercollegiate, the Fisk basketeers would produce some of the Southern Intercollegiate Athletic Conference's (SIAC) best teams. Pictured is an early 1900s photograph of a Fisk basketball squad.

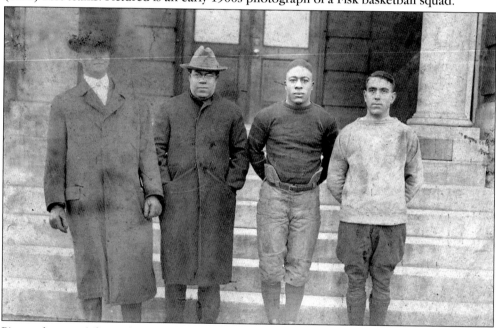

Pictured second from the right in this early 1920s photograph is Henderson A. "Tubby" Johnson. A former football star at Fisk, Johnson was a longtime coach and athletic director for his alma mater. After leaving Fisk as a football standout, Johnson was employed at Clark University in Atlanta as their first full-time coach. During his short stay, Johnson laid the foundation for the famed "Black Battalion of Death." After one year he was called back to Fisk to coach. Today, the athletic gymnasium at Fisk is named for Tubby Johnson.

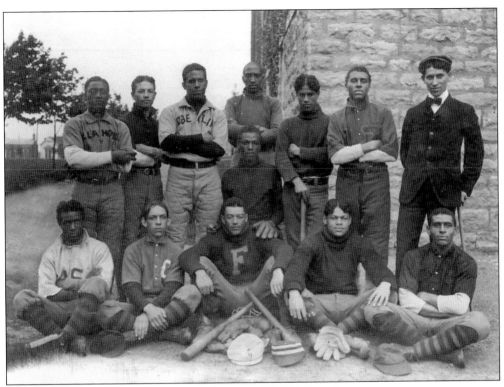

Pictured here is an early 1900s baseball team of Fisk University.

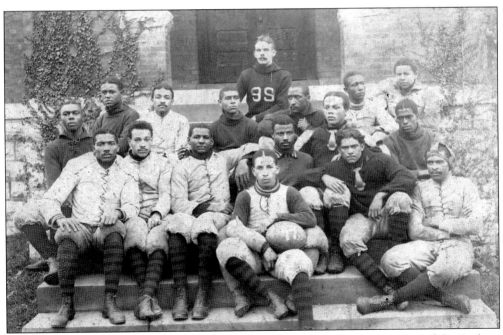

This photograph shows the "Sons of Milo" football team of 1899. (Courtesy of the Rodney T. Cohen Collection.)

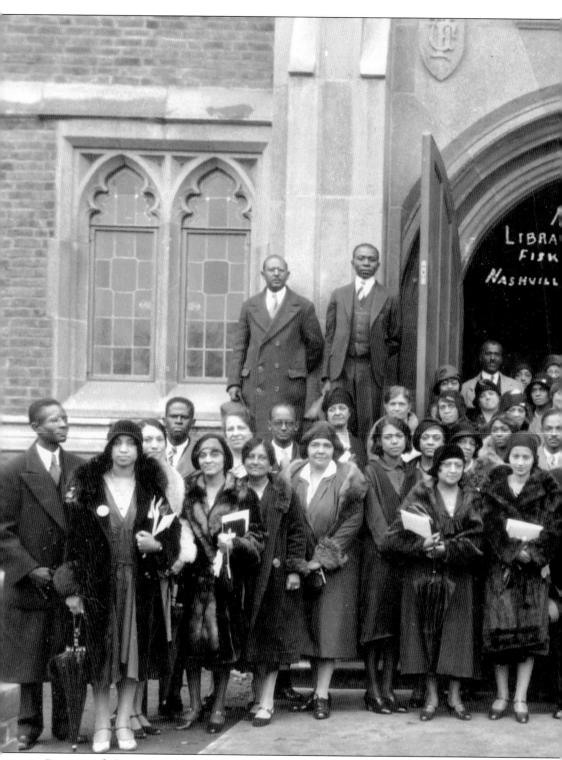

Because of the outstanding academic reputation of Fisk, the university often served as host for many academic and collegiate conferences. This photograph shows some of the

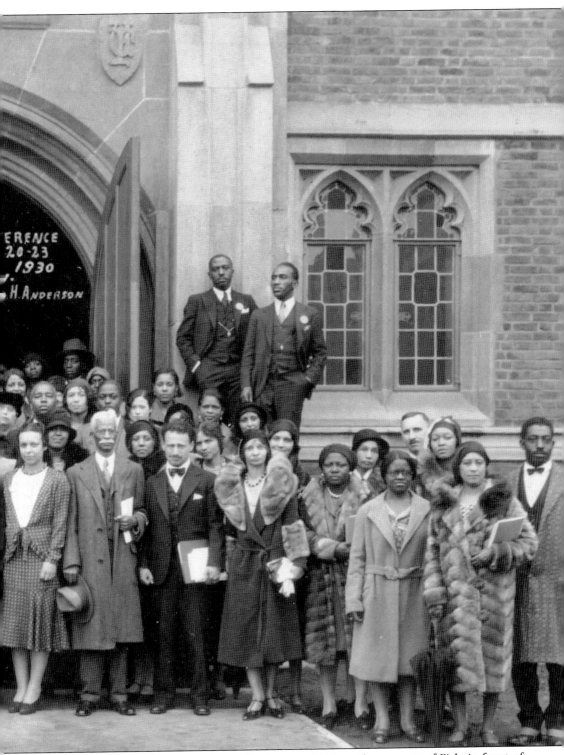

participants of the 1930 Negro Library Conference, held on the campus of Fisk, in front of the Erastus Milo Cravath Library.

21

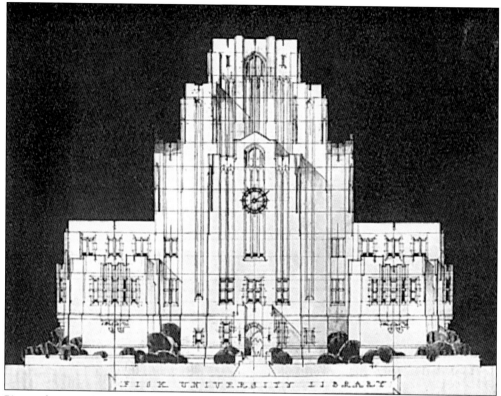

Pictured is a schematic of the Fisk University Library, now Cravath Hall. The General Education Board made the library possible through a gift of $400,000. The library was constructed as a modified collegiate Gothic structure of red brick, trimmed in intricate sandstone. The cornerstone was laid on April 26, 1930.

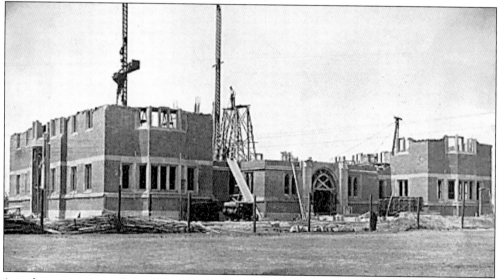

Actual construction of the Fisk Library began on the morning of January 29, 1930. The architect, H.C. Hibbs, and the construction firm were allotted approximately 200 days in which to complete the edifice.

Two

SOCIETIES AND ORGANIZATIONS

"So let my life like the ivy be…"
"Our Cause Speeds On"
"Friendship is essential to the soul"
"Achievement".
"…We pledge thee loyalty…"
"Bound by ties of love and sisterhood"
"Your very name sets our hearts aglow"
"First of All, Servants of All, We Shall Transcend All"

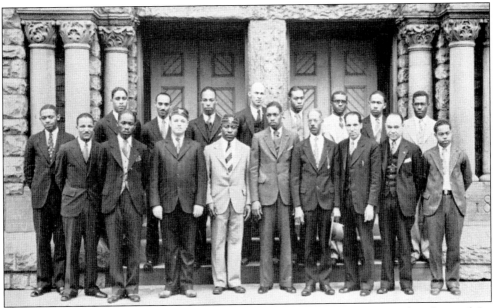

The Masons of the James A. Myers Lodge No. 349 of Nashville are pictured in front of the Fisk Chapel, 1930. Pictured in the first row, fourth from left, is Most Worshipful Master Henderson A. "Tubby" Johnson.

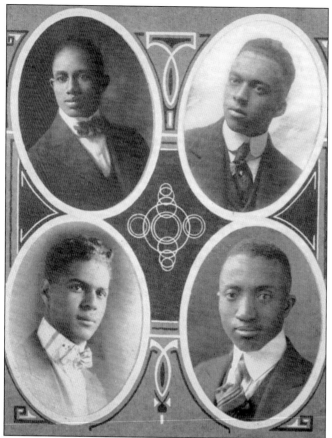

During the 1918 academic year, the Fisk University debating team, pictured here, defeated both Howard and Atlanta Universities in the 12th intercollegiate debate tournament. By defeating Howard and Atlanta, Fisk became the champion of what was known as the "Debating Triangle." Joseph A. Berry (top row, left) and Edward W. Beasley (top row, right) won the decision against Atlanta University in Nashville, and Jasper A. Atkins (bottom row, left) and Benjamin F. Gordon (bottom row, right) defeated Howard University in Washington. In addition to the "Triangle," Fisk was also a member of the "Pentagonal" Debating Conference composed of Knoxville College, Morehouse, Talladega, and Johnson C. Smith.

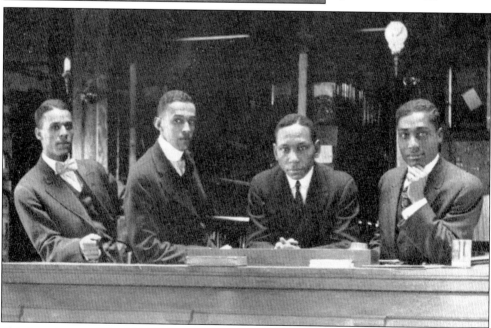

This is an image of the 1916 Fisk University Debate Team.

1918

Atlanta=Fisk=Howard

DEBATE BETWEEN

Atlanta and Howard

Held in Ware Memorial Chapel, April 5th, 1918

SUBJECT

Resolved: That universal compulsory military training should be adopted as a permanent policy by the United States.

SPEAKERS

Atlanta University, *Affirmative*

Roscoe Thaddeus Cater, '18
Albert Asbury Edwards, '19
Clayton Russell Yates, '20, *Alternate*

Howard University, *Negative*

Arthur Charles Payne, '19
Thomas Benjamin Dyett, '18
John P. Murchison, '20, *Alternate*

JUDGES

Mr. Willis Everett, Judge W. R. Hammond, Rev. J. Sprole Lyons, D.D.

Opening speeches, eighteen minutes each.
Rebuttal, seven minutes each.

Debaters — 1919 War- debate omitted
1920 Stinson & Greenwood
1921 Pages McLendon
22 Page & Russell
23 Pendleton & Bohannon

Pictured here is a program from the sixth intercollegiate Triangular debate between Howard and Atlanta, which was held at Atlanta University's Stone Hall.

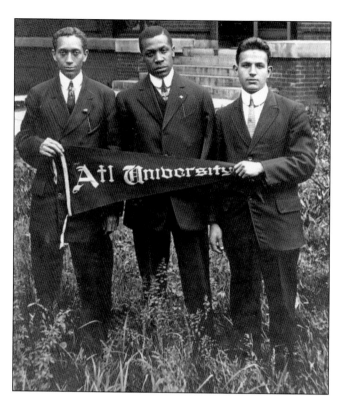

Pictured here is a *c.* 1918 Atlanta University debating team that competed against Fisk in the debating triangle.

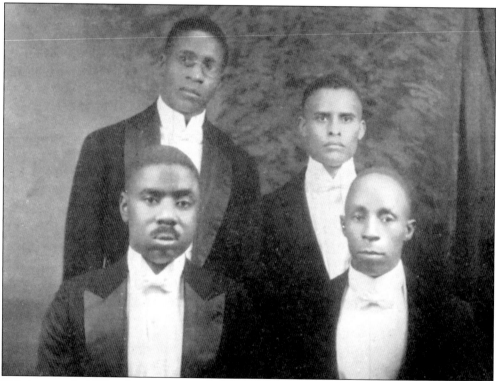

This is an early 1920s photograph of a Howard University debating team.

This is the Fisk Memorial Chapel where many of the Fisk-Atlanta-Howard debates took place.

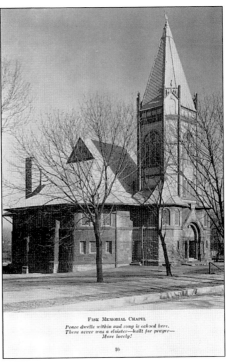

FISK MEMORIAL CHAPEL

Peace dwells within and song is echoed here.
There never was a cloister—built for prayer—
More lovely!

16

Stone Hall at Atlanta University, shown here in 1918, was where many of the triangle debates took place. Irony would have it that Fisk alum W.E.B. DuBois, while on the faculty of AU, would write his book, *The Souls of Black Folk*, from Stone Hall.

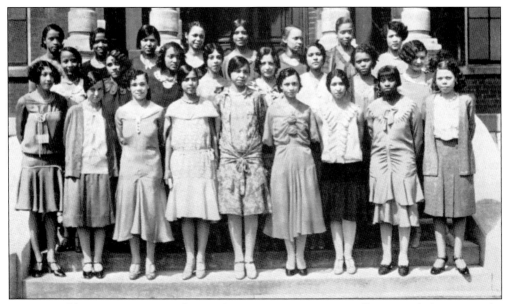

In 1900, Athlea Brown organized "Duodecem Literae Virgines," affectionately known as the DLV Club. Early in its history membership was limited to students pursuing the classics and science. In addition, the club was limited to 12 members (as its name suggests) but later expanded to include larger numbers. The club aimed to prepare women for leadership while developing and cultivating aesthetic and literary tastes. The DLV studied such subjects as the Negro in art, John Erskine, the status of the Negro woman in society, and the works of Amy Lowell. Pictured is the DLV Club in 1916.

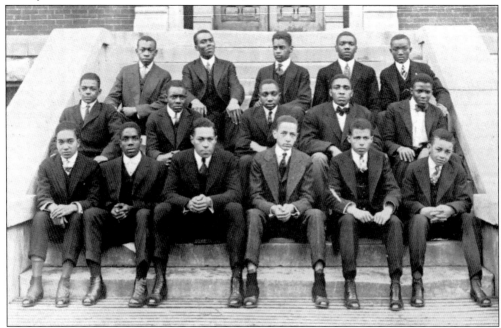

Prior to the arrival of the fraternal movement in the mid-1920s, Fisk hosted a number of literary societies on campus. Pictured here in 1915 is one of those societies, the Union Literary Society.

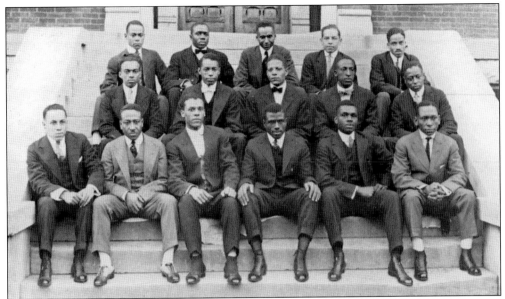

In October of 1894, nine Fisk men met for the purpose of organizing a literary club known as Excelsior in order to discuss the topics of the day. Over time, the club accumulated a fine library that they often increased. C.C. Poindexter was a member/advisor to the club and, prior to coming to Fisk, had also been instrumental in the development of the Alpha Phi Alpha Literary Society (later Fraternity) at Cornell University. The club's flower was the white carnation and their colors were purple and light blue. Here is a c. 1916 photograph of the Excelsior Club.

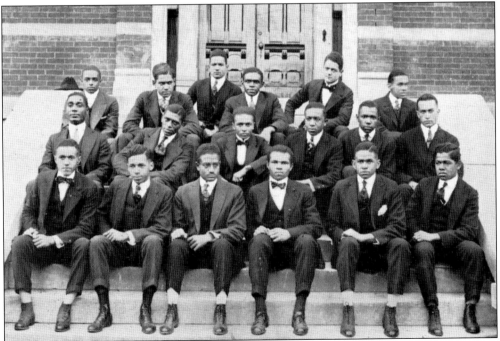

The Dunbar Club was established in the 1910s for the purpose of studying literature. Pictured here is the Dunbar Club of 1916.

29

This is a *c.* 1919 photograph of the Fisk YMCA. Professor Adam K. Spence first brought the YMCA concept to Fisk in 1887, and it is believed that Fisk was the first black college in the country to host a YMCA group.

Pictured above is one of the many Fisk literary societies of the 1910s. This one was known as Extempo.

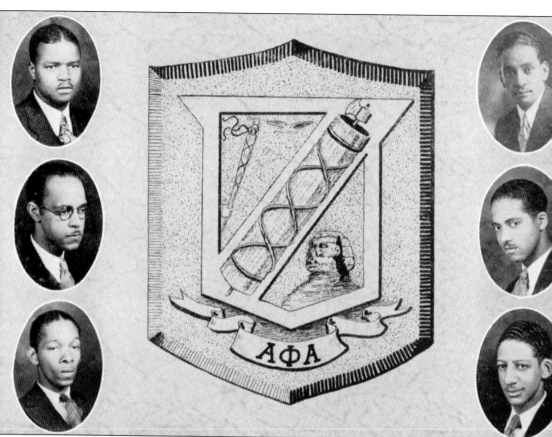

In 1956, one of the seven founders or "Jewels" of the Alpha Phi Alpha Fraternity—Henry Arthur Callis—referred to Fiskite W.E.B. DuBois as an "inspiration for Alpha Phi Alpha." DuBois himself would go on to become an exalted member (Epsilon Chapter, 1909) of the organization he influenced. With this membership, DuBois would petition early on for the existence of an Alpha Chapter at Fisk. DuBois's argument for Alpha at Fisk highlighted the serious efforts made by the fraternity to promote blacks in higher education through its national campaign of "Go to High School, Go to College." Because of Fisk's resistance to the fraternal movement, Alpha was unable to establish a chapter until the late 1920s; this long-awaited birth took place on December 3, 1927, as the Alpha Chi Chapter. Its initiation list reads like a Who's Who, including such men as historian John Hope Franklin and A. Maceo Smith, the 17th general president of Alpha Phi Alpha. This 1929 photograph represents the chapter officers of Alpha Chi.

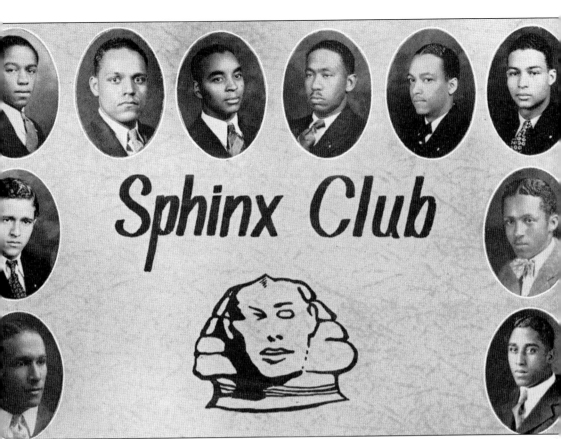

The Sphinx Club, named after the fraternity's spiritual symbol, is the name given to the pledges of Alpha Phi Alpha Fraternity. These 1930 pledges were aspirants to the Alpha Chi Chapter.

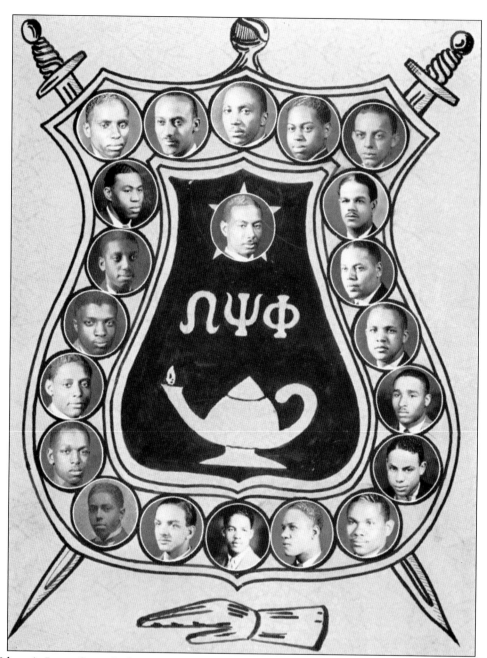

Edgar A. Love, Oscar J. Cooper, Frank Coleman, and Professor Ernest E. Just founded the Omega Psi Phi Fraternity on the campus of Howard University on November 17, 1911. These men established the first, or "mother," chapter of a black Greek-letter fraternity to be founded at a historically black college. The principles upon which Omega is based are set forth through: Manhood, Scholarship, Perseverance and Uplift. The Eta Psi Chapter was founded on April 28, 1926, by Omega men of Tennessee A&I State College and Fisk University, in association with William Gilbert, a charter member of the "mother" chapter. In 1928, the charter was revised to include only men of Fisk. Pictured is a 1929 photograph of the Eta Psi Chapter.

The group pictured here is of the Interfraternity Council, *c.* 1930, composed of a representative from each of the Greek-lettered groups at Fisk: Alpha Phi Alpha, Alpha Kappa Alpha, Omega Psi Phi, Delta Sigma Theta, Kappa Alpha Psi, Phi Beta Sigma, and Zeta Phi Beta. The purpose of the organization was to assist in establishing and developing a spirit of cooperation and camaraderie among the fraternities and sororities.

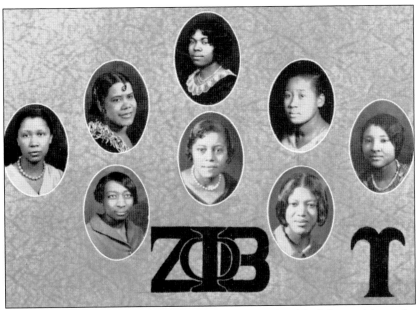

Zeta Phi Beta Sorority joined the tradition of many of the other black fraternities and sororities by being established at the "Capstone of 'Negro' Education"—Howard University—on January 16, 1920. The Upsilon Chapter of Zeta Phi Beta Sorority was chartered at Fisk less than a decade later in December 1928. Its charter members included Tommie Calhoun, Ada Dickerson, Bertha George, Anna Mae Pattillo, and Ophelia Settle. The Zeta Phi Beta Sorority includes in its membership such women as songster Sarah Vaughan and writer Zora Neale Hurston.

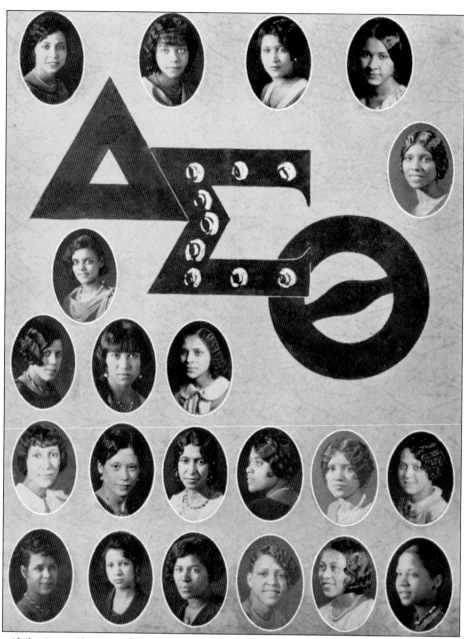

The Alpha Beta Chapter of Delta Sigma Theta Sorority was founded at Fisk on March 13, 1926, just 13 years after the sorority's development at Howard University. Since then Alpha Beta has played a significant role in the social and academic culture at Fisk. During the 1929 school year, for example, the Alpha Beta Chapter had the distinction of leading the other fraternities and sororities in scholarship. This was the first time in Fisk history that such a rivalry existed at the fraternity and sorority level. Over the years, the Deltas were known for sponsoring the annual Debutante Ball, the SP Dance, and Job Opportunity Week; in addition, the pledge club sponsored an annual reading hour for the children in the pediatric ward at Meharry's Hubbard Hospital. Pictured above is the Alpha Beta Chapter, c. 1930.

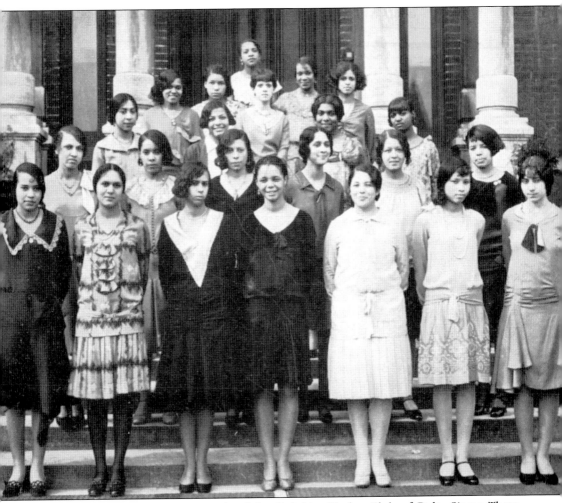

Shown here is a *c.* 1929 photograph of the Delphite Pledge Club of Delta Sigma Theta Sorority, Alpha Beta Chapter.

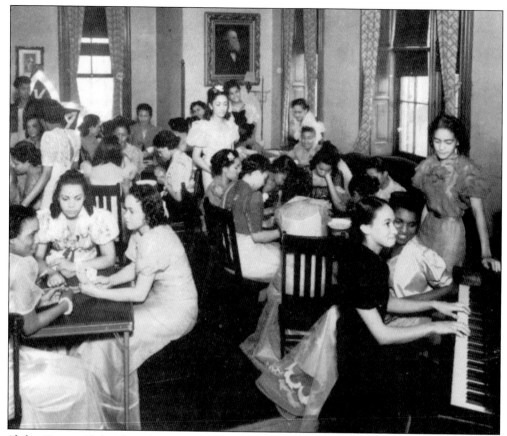

Alpha Kappa Alpha Sorority was established on the campus of Fisk in 1927; however, their origin in Nashville occurred much earlier. Not unlike many of the other fraternities and sororities at Fisk, the AKA chapter originated at Meharry Medical College in 1921 as Pi Chapter. After a series of student protests and pressure from outside constituents, the board decided to open the campus to fraternities and sororities in 1926. Shortly after that, Pi Chapter was transferred to Fisk. Prior to the transfer, many Fisk women entered AKA through Meharry. Pictured is a 1940s view of Pi Chapter hosting a social in Jubilee Hall.

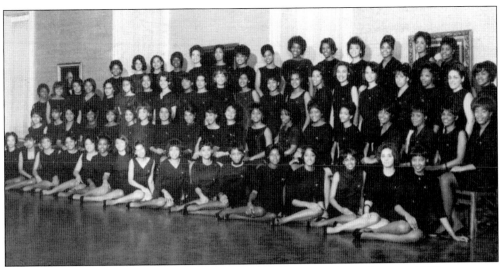

The Pi Chapter of the Alpha Kappa Alpha Sorority at Fisk is shown here in 1966.

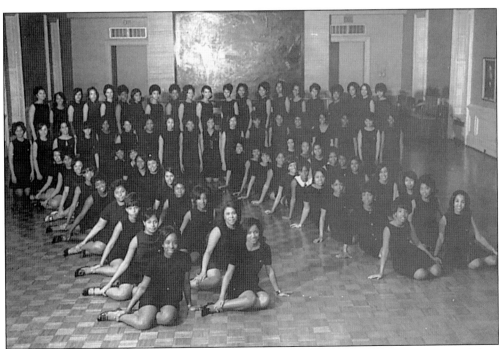

This 1969 photo of Alpha Kappa Alpha forming the greek letter Pi, representative of their chapter, was taken in the Appleton Room in Jubilee Hall.

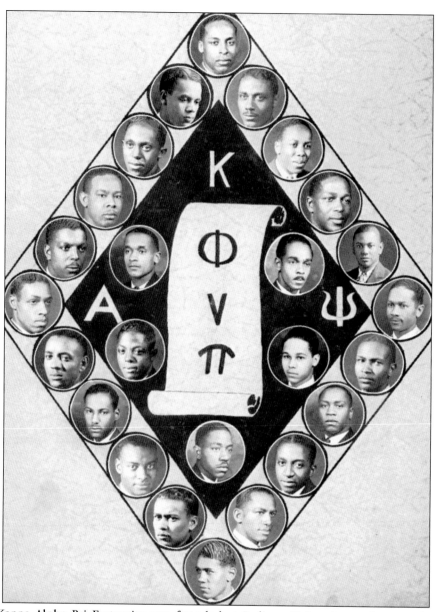

The Kappa Alpha Psi Fraternity was founded at Indiana University on January 5, 1911, and prides itself on being the only fraternity with its Alpha Chapter at Indiana University. The next chapter established by Kappa was at the University of Illinois just two years later. From this seed, other early chapters sprang up in the Midwest and East. As the fraternity continued to expand, it looked South for additional chapter seats. Following in the tradition of Alpha Phi Alpha, Kappa would only look to those institutions with an "A" rank. For this reason, the only schools at that time eligible to hold a chapter south of the Mason-Dixon line were Meharry, Morehouse, and Johnson C. Smith. Joining this roster of A-rank schools would be the Alpha Delta Chapter at Fisk, which came into existence on January 7, 1927. Since its development, Alpha Delta has produced men of rank such as James A. Lunceford, famous orchestra leader of the Chickasaw Syncopators. Pictured is the Alpha Delta Chapter, *c.* 1929.

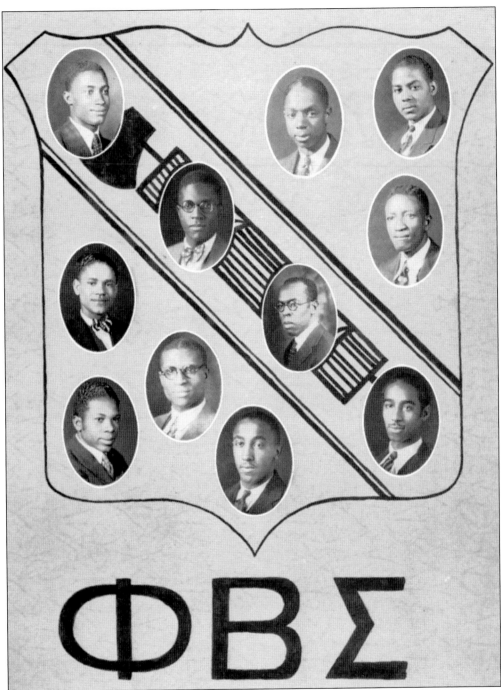

Brotherhood, Service, and Scholarship are the three major ideals of Phi Beta Sigma Fraternity and are further expressed in their motto, "Culture for service and service for humanity." On January 9, 1914, A. Langston Taylor, L.F. Morse, and C.D. Brown founded the fraternity on the campus of Howard University. The Alpha Gamma Chapter at Fisk was established during the winter quarter of the 1927–1928 school year. Pictured is the Fisk Chapter, c. 1930.

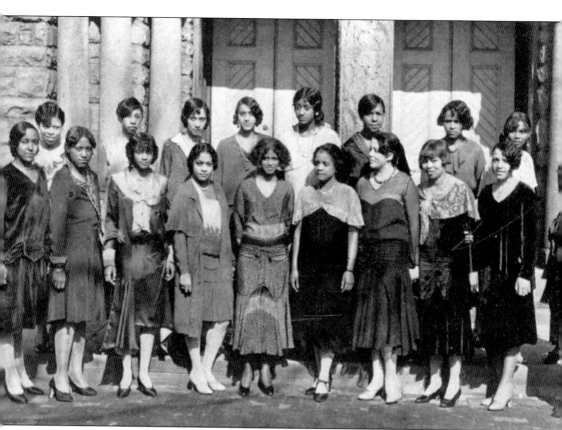

The Harmonia Club of Fisk was a musical club whose origin dates back to 1905. At first only students of harmony were admitted for membership, but later the group was opened to all students who desired musical engagement. The primary purpose of the club was to instill in its membership an appreciation for beautiful music, as well as to study the compositions of contemporary artists. In this c. 1930 photograph are, from left to right, (front row) Helen Work, Katherine Haygood, Dorothy Shepard, Mary Belle Shaw, Lucy Belle Wheatley, Lydia Mason, Irma Burwell, Emmaline Hardwick, Mayola Givens, and Marjorie Givens; (back row) Pauline Trimble, Elsa Lewis, Nannie Marshall, Marie Walden, and Harriet ?.

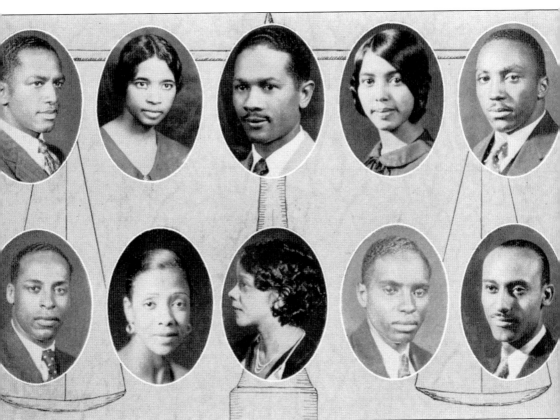

The Student Council, pictured here *c.* 1930, represents the supreme student governing body of that time. The council was organized for the purpose of developing a spirit of cooperation with faculty and students while encouraging student initiative and activism.

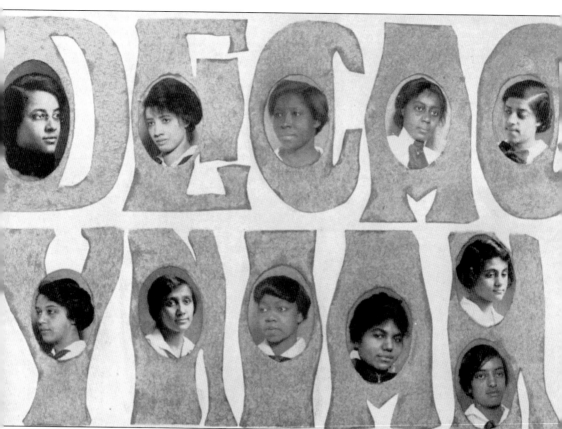

In 1899, the Decagynian Club was founded as the oldest literary club for women at Fisk by six young women of the college and normal departments. Originally, these women belonged to another club know as "Lyceum," the only organization at that time for women. After defecting from the Lyceum, these women, along with four others, formed the Decagynian Club. Their purpose was to study the important questions, literary and practical, with which they believed all women of college training should be acquainted. The name of the organization was assigned to them by one of their beloved faculty, Professor Frederick A. Chase. When approached by the members about a name, Professor Chase replied humorously with, "Call yourselves the Decagynians—the ten married women." Pictured here is a c. 1916 group of Decagynians.

Three

HER TRADITIONS, LEADERS, AND STATELY MANSIONS

*I know of no other institution of like character
that has held so constantly to high standards and ideals.*

—Chancellor James H. Kirkland, Vanderbilt University, *c.* 1912

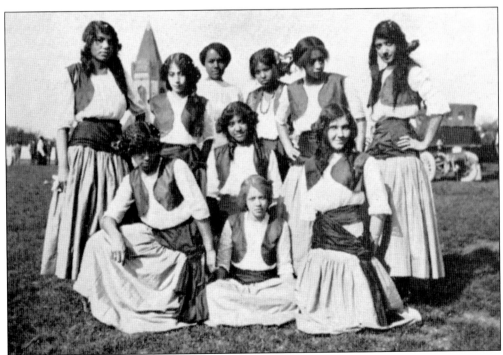

A group of Fisk dancers, *c.* 1915, participate in the annual Spring Day celebration. Spring Day was started in 1913 by Fisk professor C.C. Poindexter as a day of "fun and pleasure," and its initial intent was to raise money for the athletic program at the university.

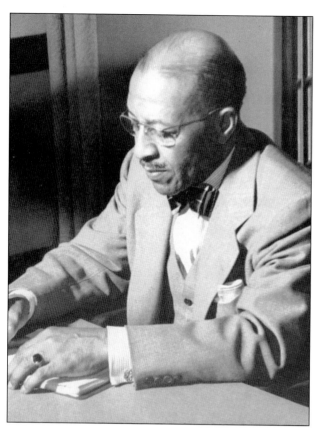

Charles Spurgeon Johnson was the first African-American president of Fisk University and was selected by the board of trustees in October 1946. Prior to becoming president, Johnson distinguished himself as a noted sociologist, having written 17 books, chapters in 14 other books, numerous book reviews, and over 70 articles, and serving as editor to 3 magazines. It was under the leadership of Charles Spurgeon Johnson that Fisk obtained a chapter of Phi Beta Kappa and memberships in the American Association of University Women and the Association of Schools of Music. During that period, the endowment also increased significantly and the physical plant was expanded with the construction of the Henderson A. Johnson Gymnasium.

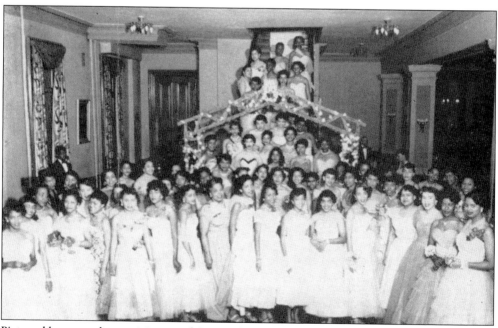

Pictured here are the participants of the 1954 Jubilee Hall Night. "Moonlight and Roses" was the theme of that formal event held in the foyer of Jubilee Hall.

"The Rocks," according to Minerva Johnson (1927), "is a landmark to generations of Fisk women." These rocks, located behind Jubilee Hall, on what was at one time referred to as the Jubilee campus, once served as a boundary line for the students of Fisk and as a place of retreat for contemplation and reflection.

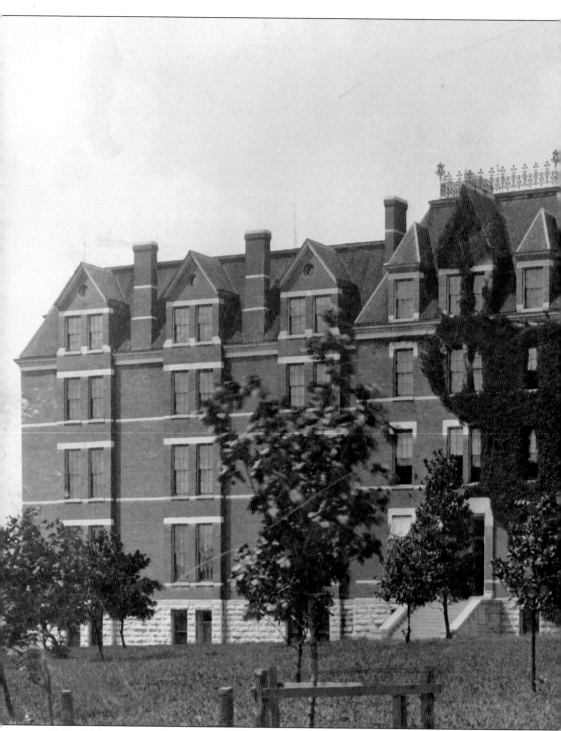

"Old" Livingstone Hall, "the companion building" (as it was known during the period) to Jubilee Hall, was erected in 1882 with a gift of $60,000 from Mrs. Valeria G. Stone of Massachusetts. The movement to construct Livingstone also had its origin in the Jubilee Singers, just as Jubilee Hall had. Through their performances and influence,

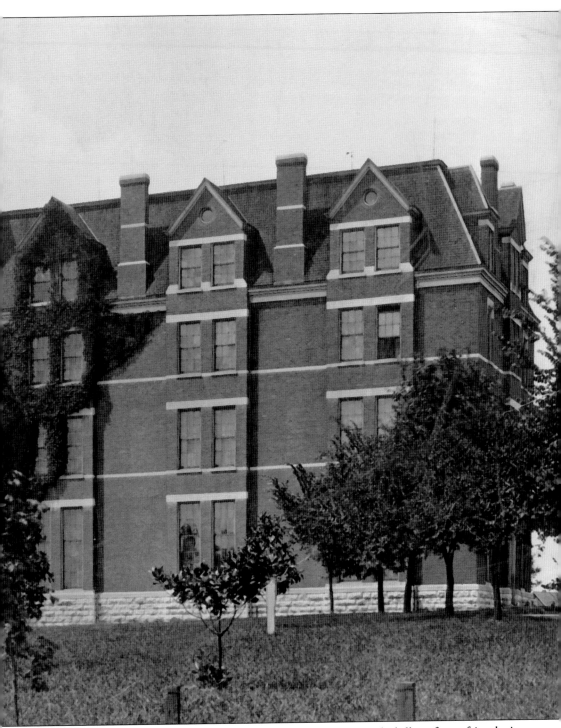

the Jubilee Singers were also able to amass several thousand dollars from friends in England, Ireland, the Netherlands, and Germany. No longer in existence, the building was once used as a combination dormitory-classroom-student union. Old Livingstone was destroyed by fire in 1969.

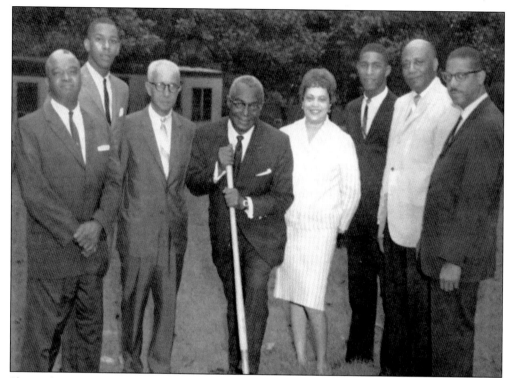

Shown here is the 1965 groundbreaking ceremony for the "new" Livingstone Hall for men, which was a replacement for and namesake of old Livingstone. Fourth from the left, holding the shovel, is President Stephen J. Wright.

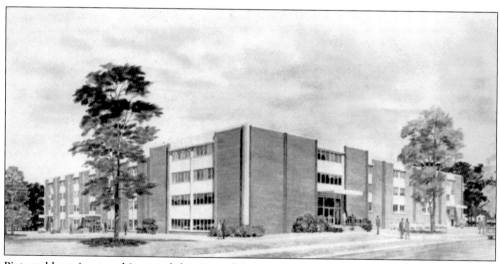

Pictured here is an architectural drawing of the new Livingstone Hall, which is today known as "New Liv."

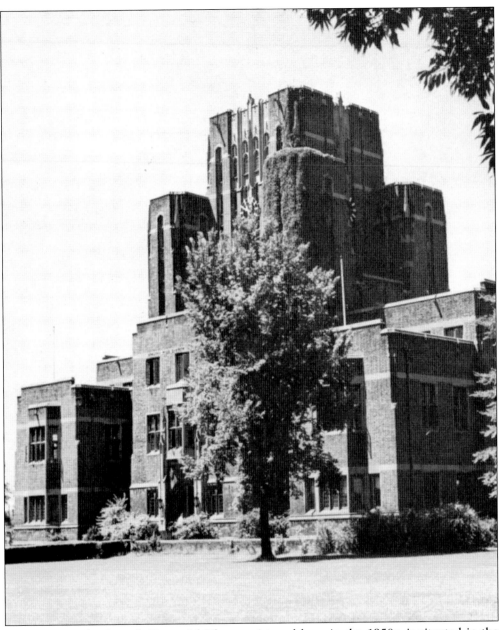

The Erastus Milo Cravath Memorial Library, pictured here in the 1950s, is situated in the geographic center of campus. Built in 1930 to serve approximately 1,000 students, the library contained shelf space for 175,000 volumes. At the time of this photograph, the collection housed at the library numbered around 145,000. Among the special collections were the Negro Collection and the George Gershwin Memorial Collection of Music and Musical Literature. Cravath Library also housed administrative offices. Today Cravath is used almost exclusively for administrative purposes.

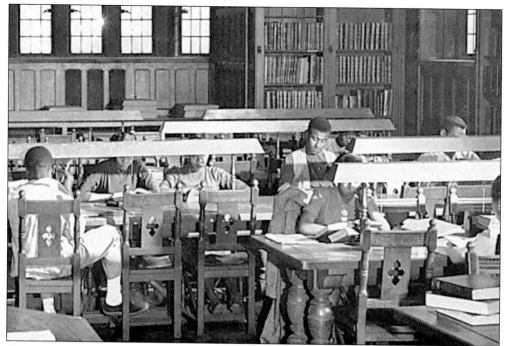

Shown above is an interior view of the reading room at the Erastus Milo Cravath Library in the 1950s.

This c. 1960s photograph shows members of Orchesis, the university's dance ensemble, as they "create beauty out of grace and balance." The dance group has been a favorite student organization over the years and adds much to the aesthetic and cultural atmosphere of Fisk.

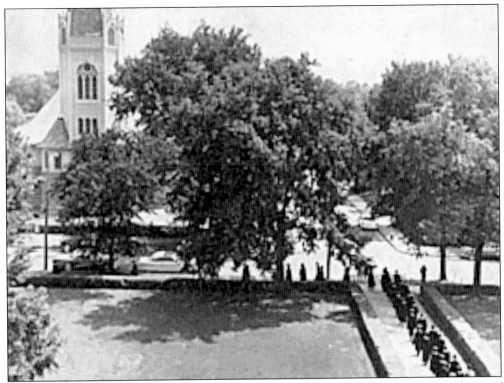

This bird's-eye view shows graduating seniors and faculty marching from the front of Cravath Hall during commencement.

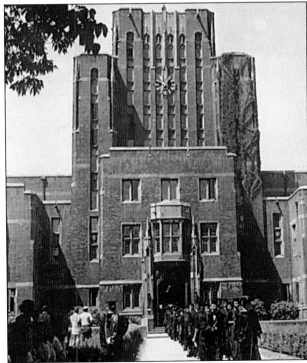

During commencement the Fisk faculty followed alongside the graduating seniors' procession from Cravath Hall onto the adjacent campus grove for the commencement proceedings. This 1953 commencement processional exits the stately structure of the Cravath Memorial Library.

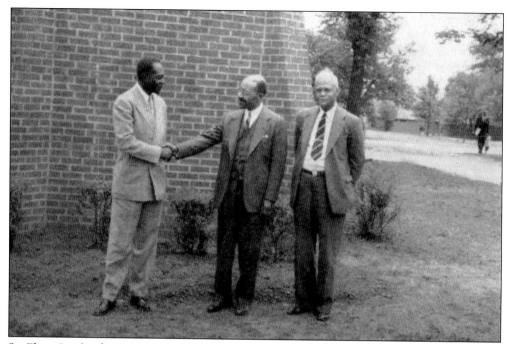

St. Elmo Brady (far right) and Charles S. Johnson (center) congratulate Carter Wesley on his donation of the Fisk Bell Tower. This photograph was taken following the dedication ceremony of the bell tower on May 1, 1948, during Fisk's 19th annual Festival of Music and Art.

Serving as the university's second African-American president, Stephen J. Wright began his nine-year tenure at Fisk in 1957. A native of South Carolina, Wright was a 1934 graduate of Hampton Institute. Prior to his Fisk presidency, Wright had served as president of the historically black Bluefield State Teachers College in West Virginia. While at Fisk, Wright distinguished himself as an outstanding administrator in "Negro" education. As a result he was recognized with many honorary degrees from such institutions as Morgan College, Notre Dame, and Colby. In addition, Wright served as a representative to the White House Conference on Children and Youth in 1960.

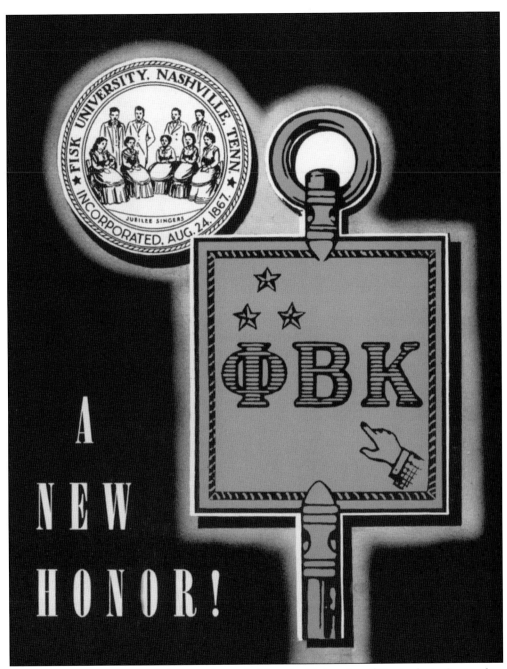

A NEW HONOR!

The triennial convention of Phi Beta Kappa held at the University of Kentucky in September 1952 authorized the establishment of a select group of chapters. Included in that list were Clark University in Massachusetts, Howard University, Ripon College, Rockford College, University of Hawaii, University of New Hampshire, University of Pittsburgh, Wayne University in Detroit, and Fisk University. Prior to the establishment of Phi Beta Kappa at Fisk, the university established the Sigma Upsilon Pi honor society in 1934 as a preparation for the establishment of a Phi Beta Kappa chapter. The founders of Sigma Upsilon Pi were Theodore S. Currier, Bertram Boyle, Elmer Imes, Harold Smith, and A.A. Taylor.

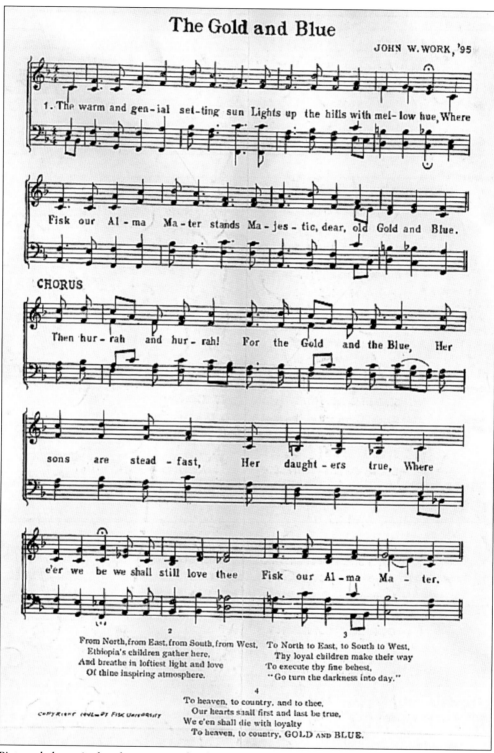

Pictured above is the alma mater of Fisk University written by John W. Work, Class of 1895. "The Gold and Blue" was copyrighted in 1946.

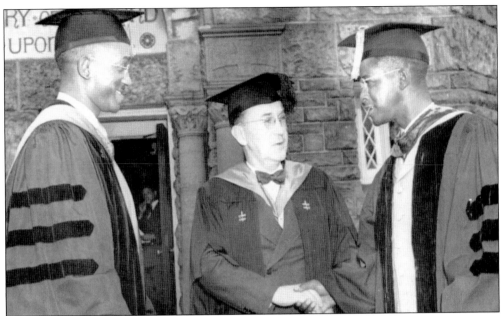

The outstanding academic reputation and achievements of Fisk received signal recognition in 1953 when Phi Beta Kappa, the oldest scholastic honor society in the country (founded in 1776), saw fit to establish the Tennessee Delta chapter at Fisk University. This 1953 photograph shows Professor Theodore S. Currier (center), president of the Tennessee Delta chapter, congratulating Dr. Fred W. Alsup (right), one of the two foundation alumni members elected, while the other alumni member, Dr. John Hope Franklin (left), looks on. In addition to Franklin's and Alsup's selections, four Fisk students were also granted membership. Fisk was the first historically black college or university to receive a chapter of Phi Beta Kappa. Some other black colleges to follow in membership included Howard and Morehouse.

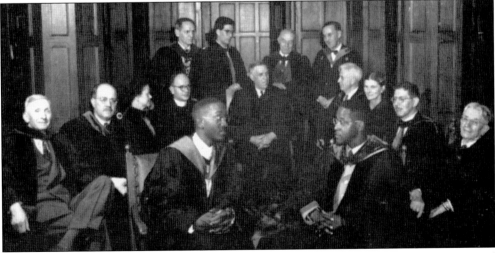

Pictured in this 1953 photograph is the Phi Beta Kappa room of the Cravath Memorial Library where the charter is being presented to the Tennessee Delta chapter. In the foreground, from left to right, are Dr. John Hope Franklin, Class of 1935, and Dr. Fred W. Alsup, 1934, M.A. 1936.

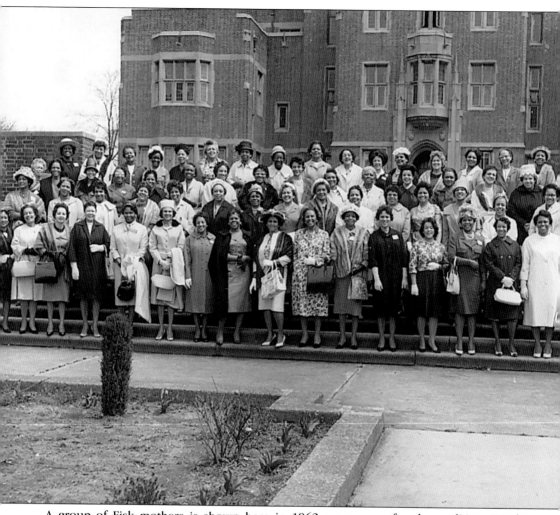

A group of Fisk mothers is shown here in 1962 on campus for the tradition "Mothers Weekend" activities.

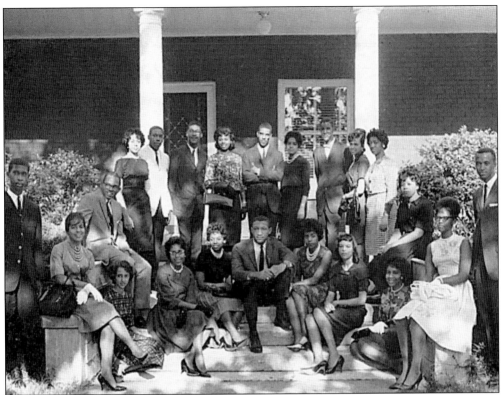

In addition to a group portrait taken of the freshman class, the Fisk tradition has also featured the sons and daughters of Fisk's fathers, mothers, grandfathers, and grandmothers. Pictured here are the Fisk legacies of the Class of 1965.

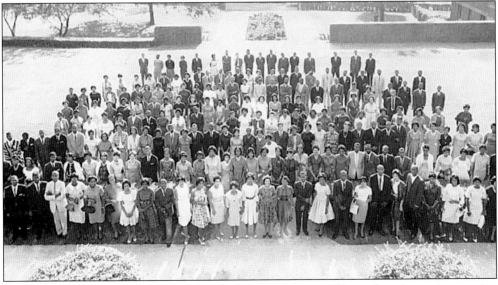

A long-standing tradition at Fisk has been the photographing of each year's entering freshman class. This is a 1961 image of the Class of 1965 taken from a bird's-eye view on top of Cravath Hall.

Economic Trends and Outlook

IN

Objective Perspective

The Eighth Annual

Workshop

ON

Economic Education

JUNE 9 - JULY 18, 1958

Sponsored by

THE TENNESSEE COUNCIL ON ECONOMIC EDUCATION
THE JOINT COUNCIL ON ECONOMIC EDUCATION

AND

FISK UNIVERSITY

ON THE CAMPUS OF

FISK UNIVERSITY
NASHVILLE 8, TENNESSEE

SESSION WILL BE HELD IN PARK HALL (AIR CONDITIONED)

The Workshop on Economic Education, co-sponsored in 1958 by Fisk and the Tennessee Council on Economic Education, was created to instill a basic knowledge of various economic systems in teachers, principals, superintendents, and community leaders. Pictured here is a program from that workshop.

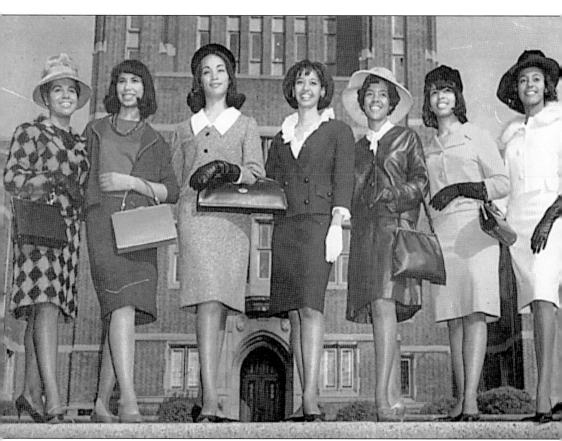

A gracious and beautiful tradition, the homecoming queen competition at Fisk, has crowned some of the most lovely and talented women, all of whom proudly represent their alma mater and organization. Pictured, from left to right, in this 1964 image are Katherine Wesley, Miss Alpha Phi Alpha; Ida Morris, Miss Bennett Hall; Judith Gunn, Miss DuBois Hall; Deborah Thomas, Miss Junior; Ramona Hoage, Miss Sophomore; Brigitte Hubbard, Miss Freshman; and Vanya Whitley, Miss Senior.

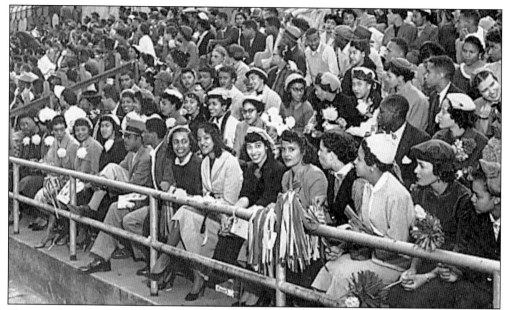

This 1954 photograph shows the homecoming crowd in attendance at the game in which Fisk defeated Alabama State, 13-12. This particular contest was held at the "all-black" Pearl High School, located just a few blocks from Fisk. In addition to using the facilities of Pearl High, Fisk would also play many of its games in the 1960s, 1970s, and early 1980s behind the Henderson A. Johnson Gymnasium. As shown in this photograph, the tradition—similar to other black colleges of the era—was to attend the game in your finest attire, complete with fedoras, corsages, and wing-tips.

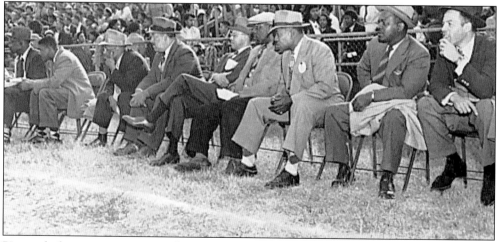

Pictured above are a group of "old" football greats viewing, with great intensity, the homecoming contest of 1954.

YELLS AND SONGS

WE GOT THE RASCALS NOW

Leader: Oh, we got the rascals!
Squad: Now, now!
Leader: Oh, Yost got the rascals!
Squad: Now, now!
(*Leader uses names of various members of team.*)

Here comes old F. U.!
Here comes old F. U.!
Here comes old F. U.!
Lie down, Howard, lie down!
Lie down, Howard, lie down!
Lie down, lie down, lie down, lie down!
Lie down upon the ground!
Lie down, lie down, lie down, lie down!
Lie down upon the ground!
Here comes old F. U.!
Here comes old F. U.!
Here comes old F. U.!
Lie down, Howard, lie down!
Lie down, Howard, lie down!

SKUTE SKUTE

When Fisk is on the gridiron,
The gridiron is hot!
Fisk can't lose with the help she's got!
When you're up, you're up;
When you're down, you're down;
When you're up against Fisk,
You're upside down!
Oh! Skute, Skute, Skute, Skute!

FF. II. SS. KK.! Fisk! Fisk! Fisk!
Yeh, team; yeh, team; beat 'em, beat 'em,
beat 'em!
Rah, rah-rah; rah, rah-rah; rah, rah-rah!
Rah, rah-rah; rah, rah-rah; rah, rah-rah!
Rah, rah-rah; rah, rah-rah! Team, team,
team!
Who? Team! Who? Team! Who?
Team, team, team!

F-I-S-K, F-I-S-K, F-I-S-K—Fisk!
F-I-S-K, F-I-S-K, F-I-S-K—Fisk!
Who? Fisk! Who? Fisk! Who? Fisk!
Fisk!! Fisk!!!

Fisk is better, better; Fisk is better now!
Fisk is better, better; Fisk is better now!

"Tubby" Johnson was a football man—um, um, um!
Born with a football in his hand—um, um, um!
Fisk is better, better; Fisk is better now—
Better, better; Fisk is better now!

"Tubby" Johnson is a good old man—um, um, um!
If the boys don't win, he'll raise plenty sand—um, um, um!
Oh, yes! She's better, better; Fisk is better now—
Better, better; Fisk is better now!

Here are some of the old-time "Yells and Songs" during the 1920s.

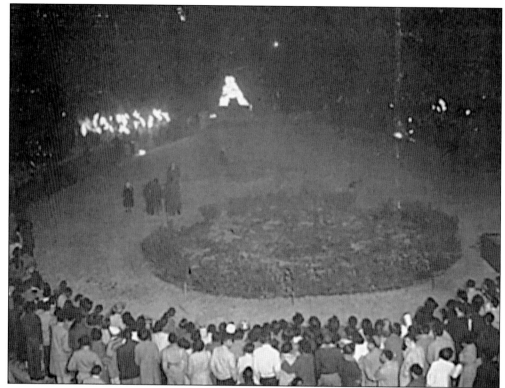

A long-standing tradition at Fisk has been the display of fraternity and sorority probates on the university's campus. For decades these presentations have been done in grand style. Pictured is a 1954 probate scene of the Alpha Sphinxmen as they march around the Jubilee Oval with the burning "A."

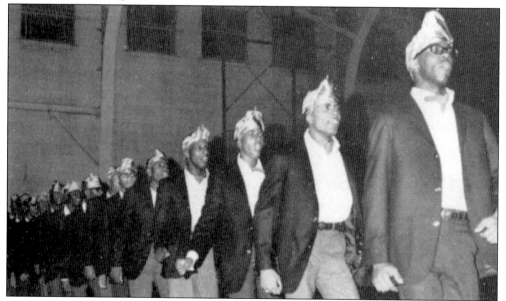

Pictured are the 1966 Omega probates of Eta Psi as they march into the Henderson Gymnasium for their pledge show.

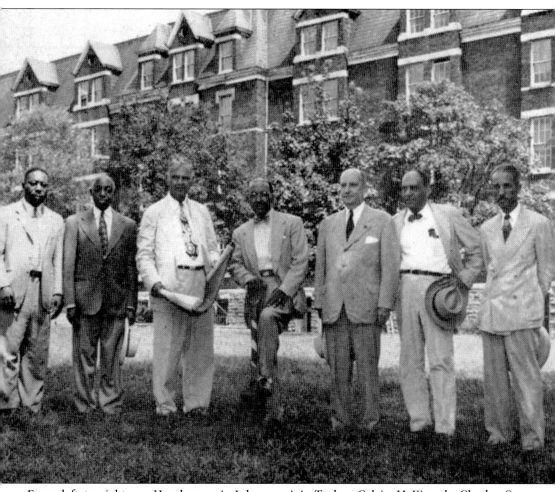

From left to right are Henderson A. Johnson, A.A. Taylor, Calvin McKissack, Charles S. Johnson, William Hume, Dan May, and I.T. Cresewell, as they prepare for the groundbreaking ceremony of the Fisk Gymnasium in November 1949.

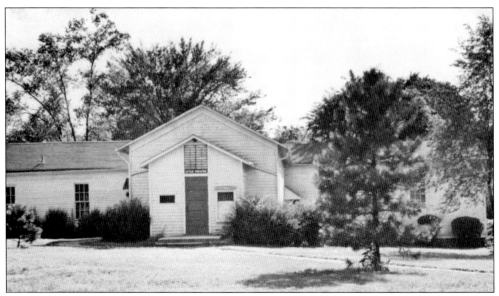

The Little Theatre, completed in 1876, is the oldest structure on the Fisk University campus. The building was constructed from two of the barracks that originally served as housing for wounded Union soldiers during the Civil War. From 1866, the year of Fisk's founding, until 1876 and the completion of Jubilee Hall, these barracks, together with an adjoining chapel, constituted the Fisk campus. Since its relocation to its present site, the Little Theatre has become the home of the Fisk Stagecrafters.

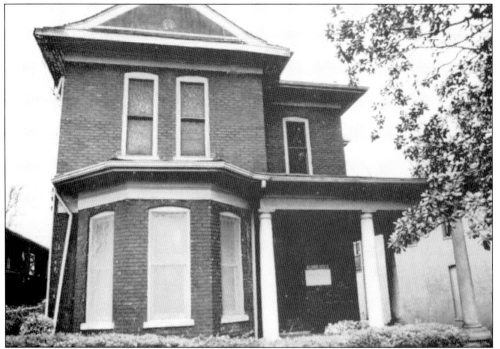

The Talley House, which is currently condemned, was once the home of famed Fisk chemistry professor Thomas Talley. The Alumni Association also utilized the building for a brief time as a hospitality house.

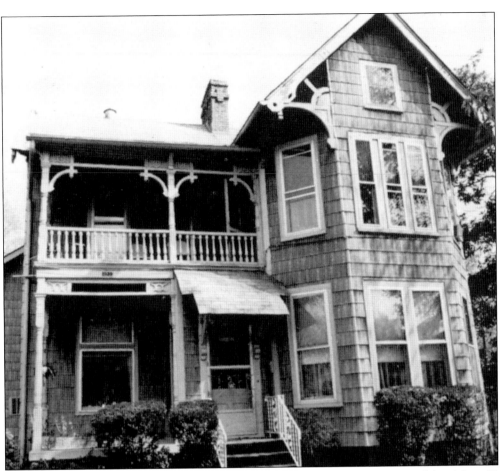

Formally known as the Spence-Work House, this building was constructed by Adam K. Spence, the second principal of the Fisk School and later assistant to Erastus Milo Cravath, the first president of Fisk. John W. Work III, the director, composer, and arranger for the Jubilee Singers from 1948 to 1957, occupied the home and lent his name to it. The Work House was also the residence of Mary E. Spence, Class of 1887, who later served as professor of Greek at Fisk; Sterling Brown, a renowned poet; and sociologist E. Franklin Frazier, the author of *Black Bourgeoisie*. Both Brown and Frazier occupied the house during their stays as professors at Fisk. Fisk purchased the house in 1937.

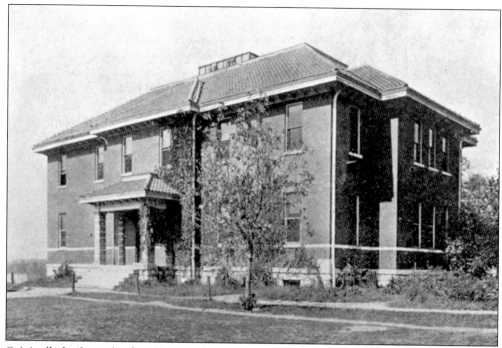

Originally built as the first library of Fisk, the Carnegie Building was made possible by a gift of $30,000 from philanthropist Andrew Carnegie. On May 22, 1908, William Howard Taft, then the secretary of war and later the 27th President of the United States, laid the cornerstone for the building. The Carnegie Building was designed by Nashville architect Moses McKissack II of the firm McKissack and McKissack, one of the oldest black-owned businesses in Nashville.

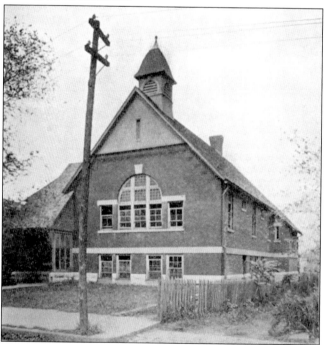

Pictured in this 1919 photograph is the Fisk Model Training School, which served as the lab school for Fisk students studying to be teachers. Many historically black colleges of that day, such as Fisk and Atlanta University, provided secondary education to members of the African-American community who did not have access to white public schools. These secondary schools attached to the colleges and universities also served as a training ground for future teachers. The current library has since replaced the Model Training School.

Built around 1875, the Magnolia Cottage, a Victorian structure of combined Queen Ann and Italianate elements, was once the home to the department of music. Fisk purchased the house in 1890. The structure, which once stood adjacent to the current music building, is no longer in existence.

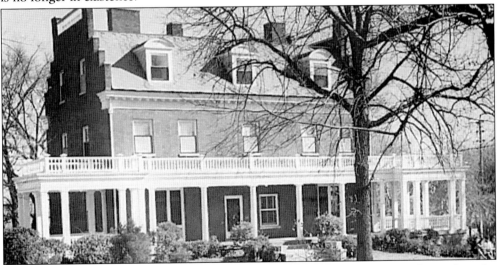

Built in 1897, this structure was known as the Heritage House. At one time located on the southeast corner of Jubilee Hall where Shane Hall is currently located, the Heritage House functioned as the president's house and was later used as the alumni house. No longer in existence, the Heritage House has been replaced by the Shane residential hall.

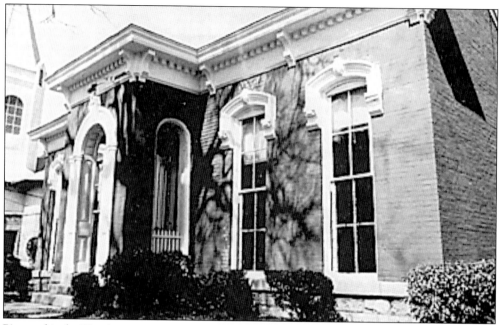

Pictured is the Harris, or Music, Annex, which was built around 1876 as the home of Richard Harris, one of the first African Americans to serve on the board of trustees at Fisk. Harris sent all eight of his children to Fisk, and one of his sons, Eugene, eventually returned to teach religion at the university in the 1890s. W.G. Waterman owned the home after Harris, and by 1909, Waterman had transferred his ownership of the structure to Fisk. In 1927, the building was used by the music department and continues in that capacity today.

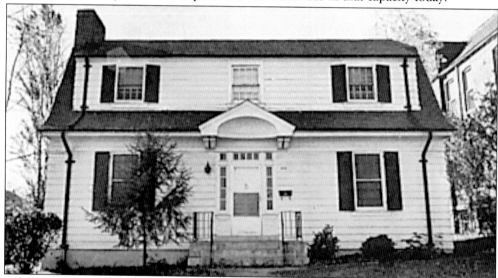

Currently located across from the Fisk Gymnasium, the Weldon House was constructed for famed author, poet, scholar, and diplomat James Weldon Johnson, who designed the building himself. While at Fisk, James Weldon Johnson occupied the Adam K. Spence Chair of Creative Literature in 1931 and taught at Fisk until 1938. A graduate of Atlanta University, James Weldon Johnson is best known for his composition of "Lift Ev'ry Voice and Sing," which became known as the "Negro National Anthem."

Erected in 1945, the Burrus Building, which is named for James D. Burrus, served Fisk, at various times, as a male dormitory, faculty apartments, and the music department. Burrus was a member of the first Fisk Class of 1875 and would later bequeath $100,000 to his alma mater.

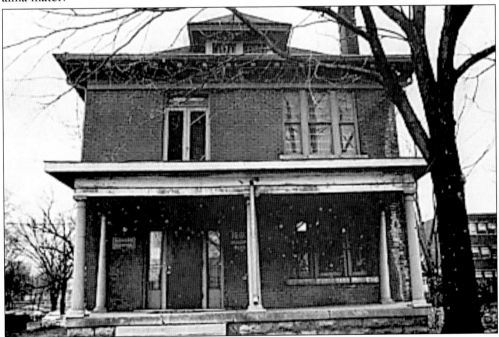

The Boyd House was the residence of its namesake, Dr. Henry A. Boyd, and was later purchased by Fisk for use as a co-op dormitory for women. It also served the university as a guesthouse and held the Honors Program and the Race Relations Institute. The Offices of Admission and Financial Aid currently use the Boyd House.

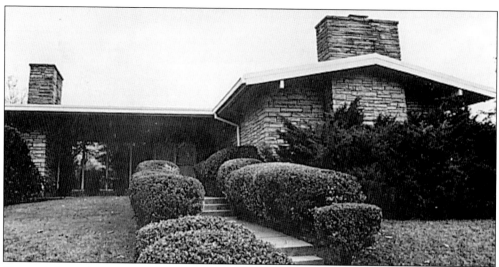

Pictured above is the current residence of the president of Fisk University. This ranch-style home was constructed for Dr. Stephen J. Wright, the seventh president of Fisk.

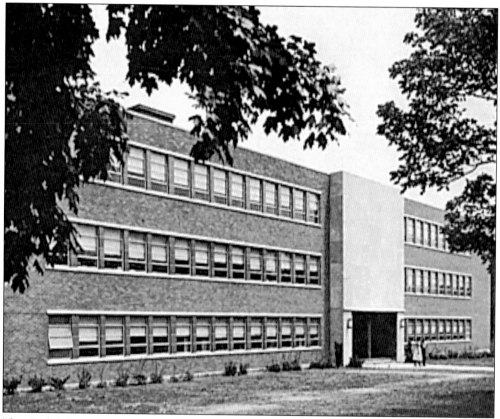

The Park-Johnson Hall was named after Dr. Robert Park, one of America's foremost sociologists, and Hall's most distinguished student and the first black president of Fisk, Dr. Charles S. Johnson. The building was opened in the fall of 1954 and was considered one of the most complete academic structures of its day.

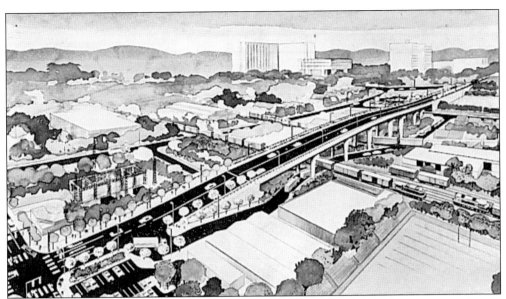

This schematic is a representation of the Jubilee Singers Memorial Bridge, which was completed in 1982. The groundbreaking ceremony in May 1980 marked the joint efforts of Fisk, Meharry, and Tennessee State; the mayor's office; the governor; and the U.S. Department of Transportation. The construction of this bridge ensured the continuous flow of traffic between West and North Nashville.

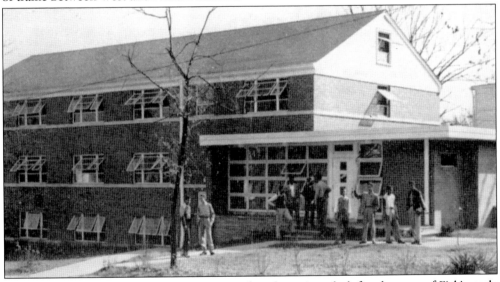

Built in 1952, the Basic College House served as the unique hub for the men of Fisk's early entrance students. In addition to living quarters, the structure included its own dinning room, lounge, and headmaster's rooms. On the bottom floor of the Basic College, there were two large classrooms for lectures. The female members of the Basic College group resided in similar environs, such as the Dunn House. Patterned in many regards after the residential college system of Harvard, Yale, Oxford, and Cambridge, the Basic College hosted a number of intellectual programs and discussion groups. For example, the Basic College once hosted an intimate lecture and dinning session with the vice-chancellor of the University of Cape Town, South Africa.

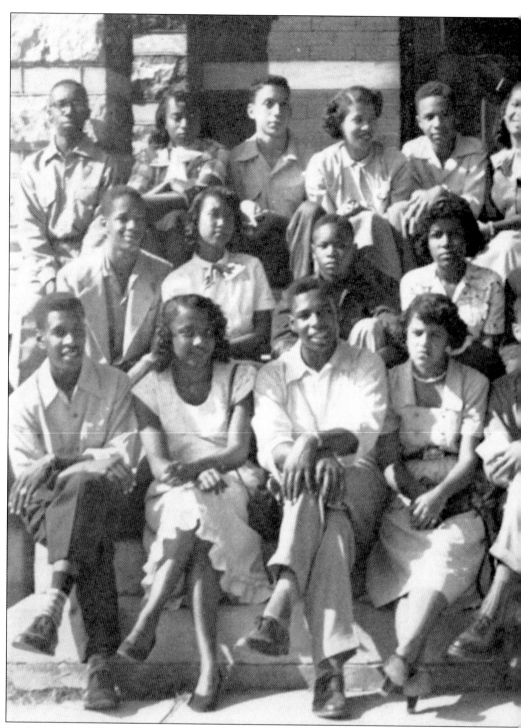

In the early 1950s, Fisk University, along with some other colleges, developed early admissions programs to their institutions whereby individuals of exceptional talent were given the opportunity to begin their college careers early. Although students already had been attending Fisk as early entrants, this was the college's first organized attempt to do

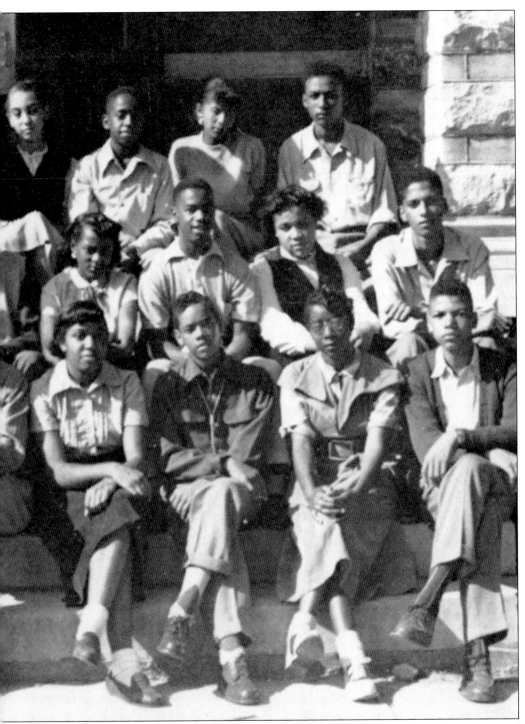

so, and the venture was funded by an outside foundation—Ford—to provide a structured format and more supportive environment. Pictured in this early 1950 photograph is the inaugural group of the early entrance program known as the "Basic College." The group would later be referred to as the Original 28.

Pictured above is a group of Basic College students as they dine and participate in discussion with a group of invited faculty members at the Basic College House.

Here, Basic College co-eds gather with the housemother of the Dunn House.

Four

FISK AND THE ARTS

Throughout the South, and in other parts of the country, blacks cherished a feeling of love and . . . reverence for Fisk . . . that is not generally understood by the rest of the world.

—Booker T. Washington

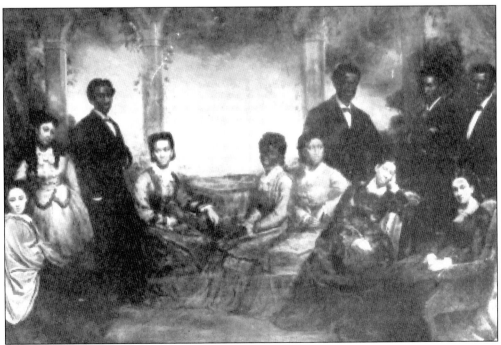

This oil painting of the original Fisk Jubilee Singers was painted by Havel, Queen Victoria's favorite artist, in London in 1873. The painting currently hangs in the Appleton Room of Jubilee Hall.

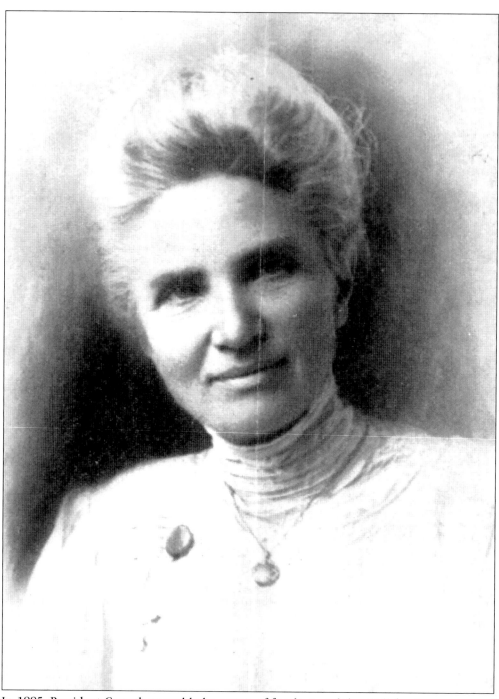

In 1885, President Cravath assembled a group of faculty in Jubilee Hall for the purpose of beginning a music department. Upon its development, the department received instant approval from the American Missionary Association. Jennie A. Robinson, pictured here, was a graduate of the Oberlin Conservatory and served Fisk for 32 years as the director of the music department. She joined the Fisk faculty in 1887. During Robinson's tenure, Fisk offered such subjects in music as public school theory and music history.

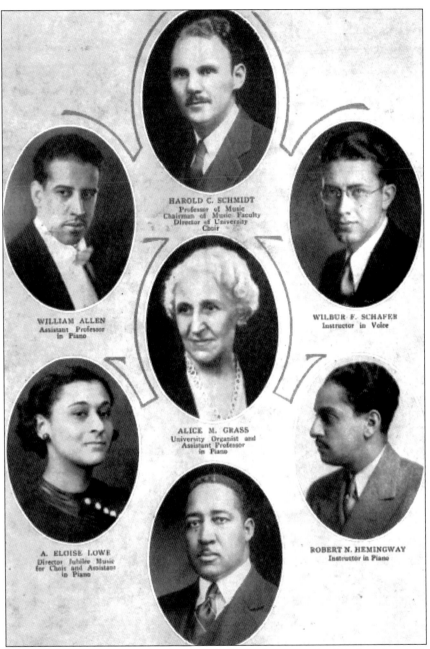

HAROLD C. SCHMIDT
Professor of Music
Chairman of Music Faculty
Director of University
Choir

WILLIAM ALLEN
Assistant Professor
in Piano

WILBUR F. SCHAFER
Instructor in Voice

ALICE M. GRASS
University Organist and
Assistant Professor
in Piano

A. ELOISE LOWE
Director Jubilee Music
for Choir and Assistant
in Piano

ROBERT N. HEMINGWAY
Instructor in Piano

This 1930s photograph shows the faculty of the Fisk University Music School. From its inception, Fisk has aimed to provide the best education possible for its students and has attracted a cosmopolitan faculty, which has been able to expose its students to the worldly delights of culture. For this reason, Fisk has produced some of the best musical education in the African, African-American, and Western tradition. By 1919, the College of Liberal Arts at Fisk gave credit toward a bachelor's degree in public school music, theory, and the history of music. In 1928, the university began to award the degree of bachelor of music (BM). In 1935, the BM degree was elevated to a master's degree; however, the first graduate work in music at Fisk began in 1933.

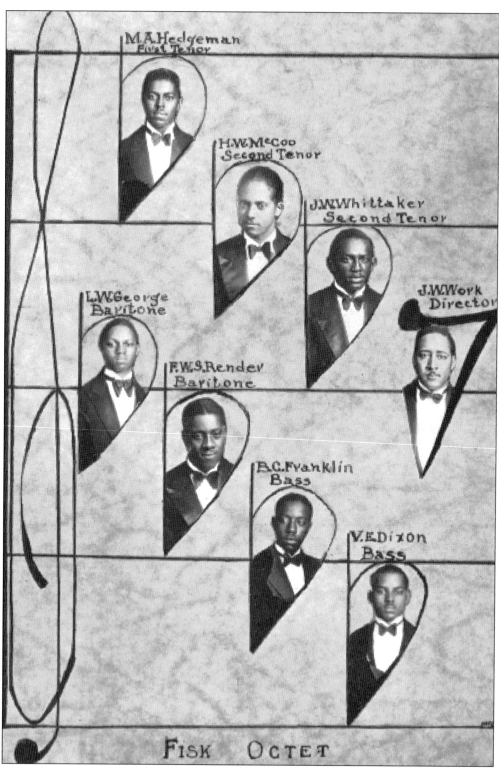

M.A.Hedgeman
First Tenor

H.W.McCoo
Second Tenor

J.W.Whittaker
Second Tenor

J.W.Work
Director

L.W.George
Baritone

F.W.S.Render
Baritone

B.G.Franklin
Bass

V.E.Dixon
Bass

FISK OCTET

The Fisk Octet was directed by John W. Work III.

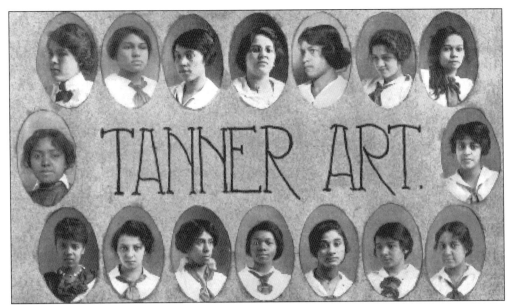

Named for noted black artist Henry O. Tanner, the Tanner Art Club was organized at Fisk in 1904. In response to a statement made by Dr. White that "An art is caught, not taught," the club was formulated to provide instruction for young female teachers in the Fisk Training School. The original 17 charter members met informally in Jubilee Hall and, there, made attempts to become acquainted with masterpieces of artists from around the world. Pictured here is a 1915 photograph of the Tanner Art Club.

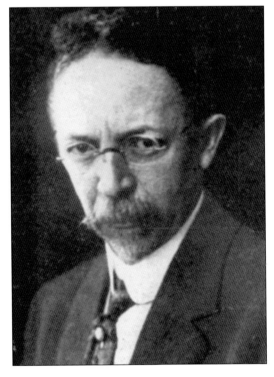

Renowned painter Henry Ossawa Tanner, for whom the Tanner Art Society was named, was born in 1859. From 1889 to 1891, he taught art at Clark University in Atlanta; he then relocated to Paris, where he remained for the most part until his death in 1937. He is best known for his painting *The Banjo Lesson*, and was considered "the first genius among Negro artists" by art historian James A. Porter.

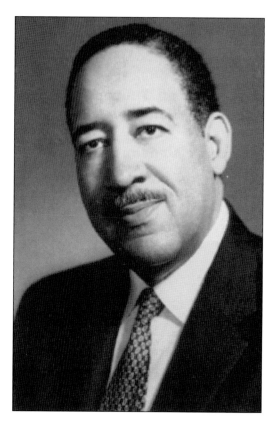

John Wesley Work III received his bachelor's degree from Fisk in 1923 and his master's degree from Columbia University in 1931, in addition to a bachelor of music degree from Yale in 1933. Work served as director of the Men's Glee Club at Fisk from 1927 to 1931 and as an assistant professor of music theory from 1933 to 1940. In 1940, Work became a full professor. He is best known as a composer of anthems, piano compositions, and vocal solos.

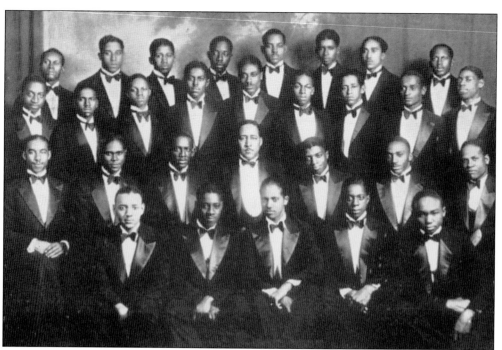

The Fisk Men's Glee Club, pictured here *c.* 1930, was directed by John W. Work III.

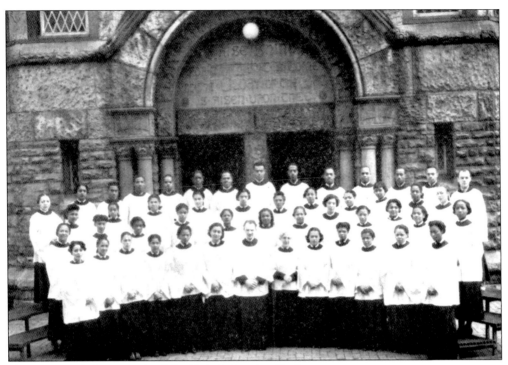

This is a 1936 photograph of the Fisk University Choir.

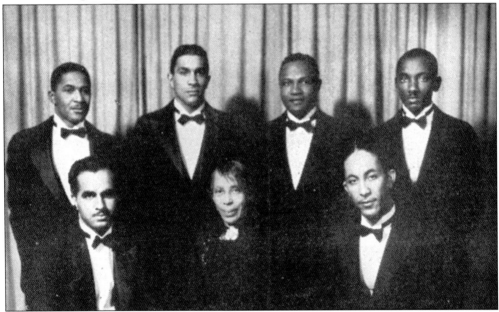

The Fisk Jubilee Singers are pictured here in 1936. Due to the outstanding tradition of music at Fisk of that day, Olga Samaroff Stokowski of the Juilliard Foundation wrote, "In many different ways I have been highly impressed with the musical work . . . at Fisk . . . Having on occasion to teach students of Fisk . . . having examined others in Juilliard . . . I have gained the conviction that the musical department of Fisk . . . is one of great significance and importance to the entire country."

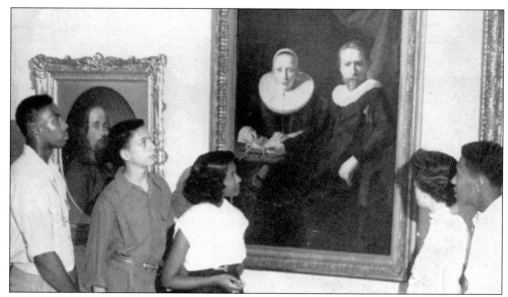

A group of Fisk students, *c.* 1960, study the outstanding collection at the Carl Van Vechten Gallery at Fisk. In the late 1940s, as a result of Carl Van Vechten's influence, along with the generosity Georgia O'Keefe—an artist and the widow of Alfred Stieglitz—Fisk became the recipient of a significant collection of art objects and paintings known as the Alfred Stieglitz Collection. It was at this point that the Carl Van Vechten Gallery of Fine Arts had its beginning. Just prior to the formal opening of the Van Vechten Gallery, Georgia O'Keefe ventured to Fisk to provide consultation on the detail and style of the gallery. The collection is represented by works from Picasso, Rivera, Cezanne, Roulouse-Lautree, Renoir, Severini, and George Grosz. The Fisk collection continues to be regarded as one of the best in the South.

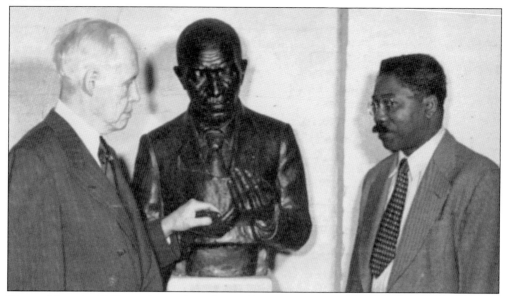

Pictured here in 1953 are Aaron Douglas (right) and Carl Van Vechten (left), for whom the Carl Van Vechten Gallery at Fisk is named. The two are viewing a bust of George Washington Carver in a section of the Van Vechten Gallery.

Aaron Douglas (left) is seen here with one of his art students at Fisk. Douglas, often regarded as the artist of the Harlem Renaissance, was a longtime professor at Fisk, where he was responsible for the creation of the murals in Cravath Hall. In addition to this, Douglas is known for his murals in Hotel Sherman in Chicago and at Bennett College in North Carolina.

Flanking the Fisk University choir is a portrait of the original Fisk Jubilee Singers, which at one time hung in the University Chapel. Due to preservation concerns, the painting was restored and relocated to the more appropriate, climate-controlled environment in Jubilee Hall.

A 1950 group of Fiskites pays tribute to the original Fisk Jubilee Singers on Jubilee Day. This long-standing tradition calls for wreaths to be placed on the graves of the four original singers buried in Nashville: Ella Sheppard Moore, Mabel Lewis Imes, Georgia Gordon Taylor, and Minnie Tate.

The Fisk University Ballet was organized in the 1950s under the direction of the physical education department. The group was comprised of those students who had some experience in ballet and those who expressed an interest in learning more about the dance form. The first public performance of the group took place in April 1953, during the Beaux Arts Ball, which was a part of the annual spring arts festival.

In 1965, Greg Ridley Jr., Class of 1949, was awarded a gold medal at the American Veterans Society of Artists Art Exhibition in New York for his sculpture entitled the "Battle of Gettysburg."

Fisk thespians perform Anouilh's modern version of *Antigone*. As one put it, "Educational theatre thrives at Fisk neither . . . for the entertainment of the public; its main purpose is to contribute to the whole educational process of the University and to the cultural experience of the student participants and audience."

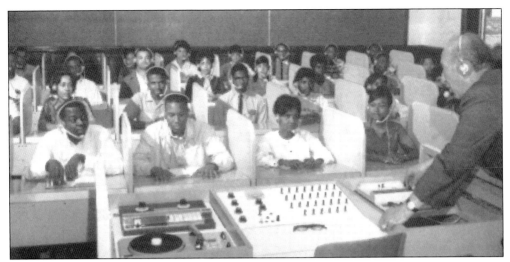

In 1963, the department of modern foreign languages opened its first language laboratory, which was able to accommodate 30 students. The lab served students interested in the subjects of German, French, Russian, and Spanish.

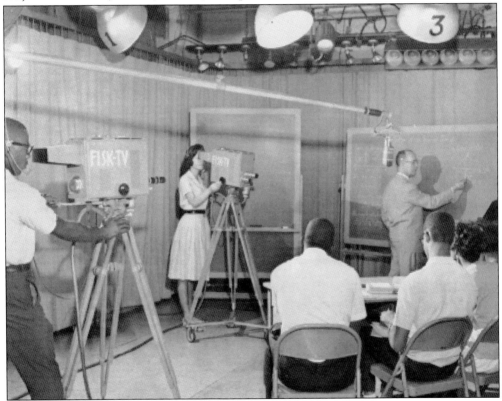

At one time Fisk's audiovisual program, designed to supplement traditional classroom instruction, was studied by many other institutions as a model. Through a central television studio located on the campus and linked by a closed-circuit system, students throughout the campus were given the opportunity to witness a lecture or eminent scholar live. This c. 1950s photograph shows a typical studio session.

TWENTIETH FISK FESTIVAL OF MUSIC AND ART

April 20-23, 1949

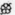

WEDNESDAY, APRIL 20

5:30-11:30 p.m. Gala Opening of Twentieth Festival. Band Concert. Crowning of Festival King and Queen. Festival Ball.

THURSDAY, APRIL 21

4:00 p.m. Opening of Exhibition of 19th Century French painting at International Student Center. Tea at International Student Center.

8:15 p.m. Concert by Helen Phillips, Soprano. Fisk Memorial Chapel.

FRIDAY, APRIL 22

10:00 a.m. "The Role of the Writer in Building One World." Seminar at International Student Center, with Lillian Smith and others.
Chairman: Arna Bontemps

10:00 a.m. "New Developments in Scientific Research." Seminar. Fisk Memorial Chapel
Speaker to be announced.
Chairman: Dr. St. Elmo Brady.

2:30 p.m. Seminar on Student Writing.

4:00 p.m. Choral Speaking Program.

8:15 p.m. Concert by Josh White, Ballad-singer.

SATURDAY, APRIL 23

10:00 a.m. "The Role of the Social Scientist in International Affairs." Panel: Luther Evans, Librarian of Congress; Edwin Embree; President Charles S. Johnson.
Chairman: Dr. Preston Valien.

2:30 p.m. "Dipper Over Gimbel's"—Little Theatre.

4:30 p.m. Student Dance Recital—Livingstone Auditorium.

8:15 p.m. Concert by the University Choir.
New Cantata, "Golgotha," by John W. Work, text by Arna Bontemps.
The "Magnificat" by J. S. Bach, accompanied by members of the
Nashville Symphony Orchestra.

(10:30 p.m. Dance for University Choir, Stagecrafters, Dance Group, and Guests.)

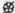

Ticket sales will begin on April 11, 1949, at the ticket office located in the University Library, Publicity Office, Room 107. Series tickets $3.00, and $1.50 for single tickets.

This 1949 schedule describes the events at the 20th Fisk Festival of Music and Art.

Five

Science at Fisk

When I went to Harvard, I found no better teachers than the ones I had at Fisk, just teachers better known.

—W.E.B. DuBois, Fisk Class of 1888

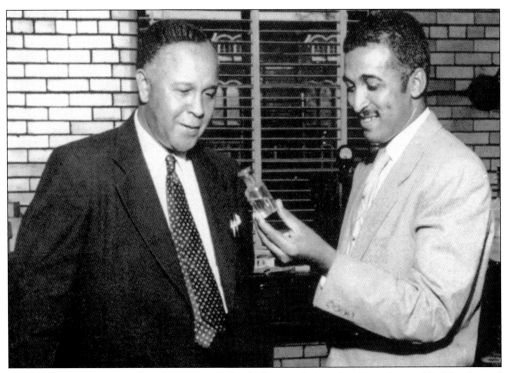

Pictured, from left to right, are renowned scholars and chemists Drs. Samuel P. Massie and Percy Julian. Both continued the fine tradition of chemical research at Fisk while serving on the faculty.

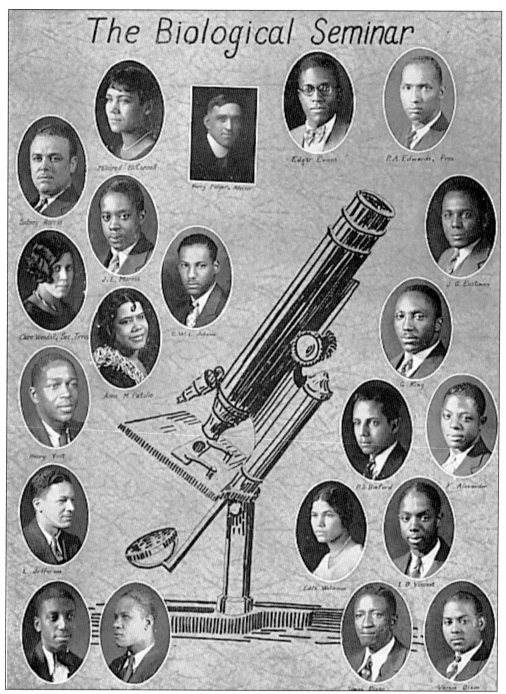

The Biological Seminar

This c. 1930 photograph shows the Fisk Biological Seminar, a group of students and faculty interested in biological sciences. The group functioned to discuss the current issues and research topics in biology and to promote the subject of biology throughout the campus community.

92

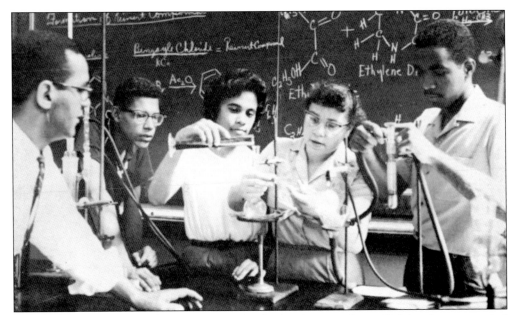

This *c.* 1950 photograph shows a group of Fisk chemistry students. Fisk has been regarded as an intellectual hub of chemistry in the world of historically black colleges.

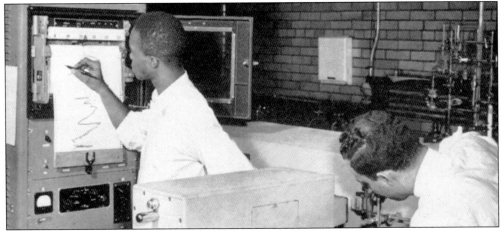

These *c.* 1960 Fisk students study molecular structure through infrared spectroscopy. The infrared tradition at Fisk can be traced as early as 1919, when Fisk alumnus Dr. Elmer S. Imes's research on the vibration-rotation spectrum of HCL vapor was published in the *Astrophysical Journal* (Vol. 50, 25, 1919). Imes, who received his doctorate from the University of Michigan, was a professor of physics until his death in 1942. Following in the footsteps of Imes was his former student Dr. James R. Lawson, also a Fiskite and Ph.D. from Michigan. Lawson went on to chair the department of physics and establish an Infrared Program at Fisk though the acquisition of a custom-built spectrometer from the University of Michigan. By the late 1940s, a French physical chemist, Dr. Marie-Louise Josien, and a Michigan physicist, Dr. Nelson Fuson, joined the Fisk faculty and promoted the development of an infrared research program. This development attracted such scientists as G.B.B.M. Sutherland, formerly of the University of Michigan and the director of the National Physical Laboratory at Teddington, England, to give a series of lectures at Fisk. These lectures gave birth to the 1st Annual Infrared Institute, which was held in 1950.

Talley-Brady Hall, pictured here in the 1960s, was once known as the Chemistry Building but was renamed, following a recommendation by the General Alumni Association, after chemists Thomas W. Talley, Class of 1890 and 1892, and his student St. Elmo Brady, Class of 1908.

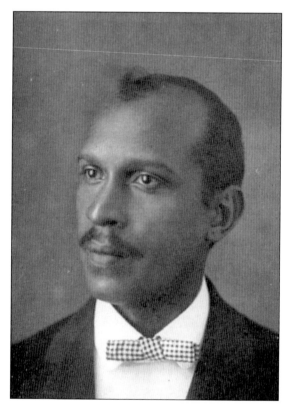

Thomas W. Talley began his studies at Fisk at the high-school level and went on to receive his bachelor's degree and master's degree (1890). After that he studied at Walden, Harvard, and the University of Chicago, where he received his master of science degree. While at Fisk, Talley was a member of the second generation of Jubilee Singers. He began his teaching career at Fisk in 1902 and succeeded his teacher and tutor Frederick A. Chase (for whom Chase Hall was named).

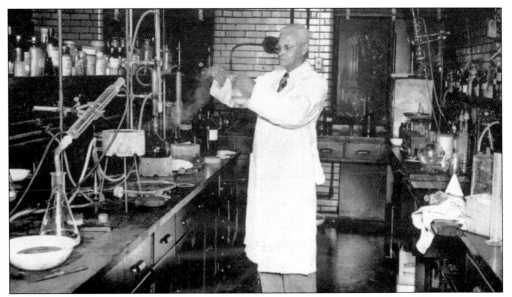

Dr. St. Elmo Brady graduated from Fisk in 1908 and later received his Ph.D. in organic chemistry from the University of Illinois in 1916. Following his studies at Illinois, Brady worked at Tuskegee, where he conducted research with George Washington Carver, and Howard University, where he headed the department of chemistry. In 1927, Brady returned to Fisk to head the department of chemistry there.

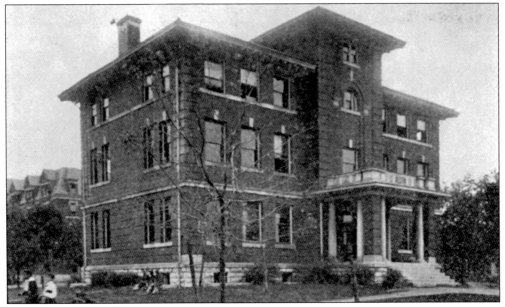

Chase Hall, seen here in 1919 and no longer in existence, was named for Professor Frederick A. Chase, who served on the Fisk faculty for 31 years. Chase came to Fisk in 1872 from the presidency of Lyons Collegiate Institute in Iowa to establish the science department. He was also the brother-in-law of Adam K. Spence, for whom Spence Hall is named. At one time, Chase Hall served as the principal building for the teaching of physics, biology, and math. Much of the early research in infrared spectroscopy by Professor Imes was conducted in Chase Hall.

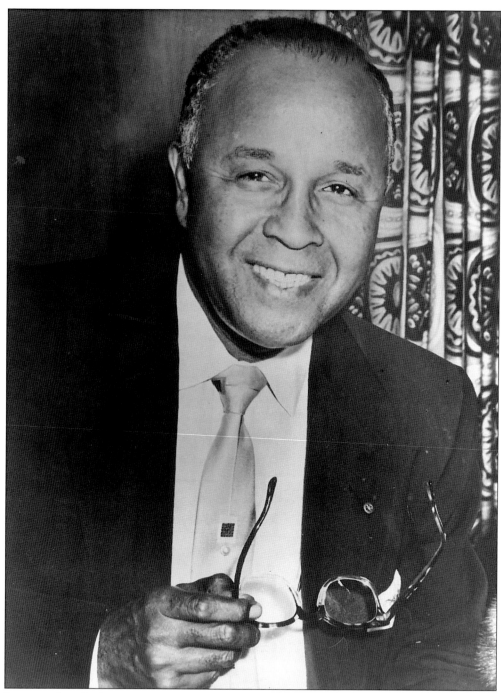

Renowned Fisk chemist Percy Julian is best known for his discovery of a way to treat glaucoma-induced blindness. He created a drug that supplemented the chemicals produced by the body to combat the disease. In 1949, for his outstanding contributions in science, he received the NAACP's Spingarn Medal, and in 1990 he was elected to the Inventor's Hall of Fame, making him the first African American to be so honored.

Six

AN ATHLETIC TRADITION

The rise of athletics at Fisk University has been one of the most colorful adventures in the history of Negro athletics. Fisk University was one of the first Negro colleges in the South to make athletics a part of its college program.

—Silver Jubilee, SIAC

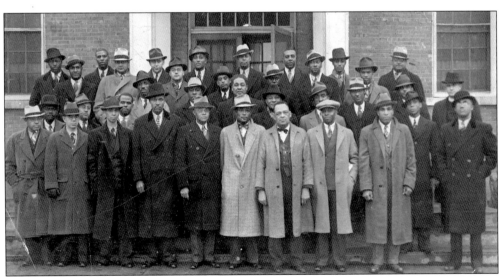

Representing Fisk in this 1930s group of athletic officials from the member colleges of the Southern Intercollegiate Athletic Conference (SIAC) is St. Elmo Brady (fifth from the left). Brady served as president of the SIAC during the mid-1930s. Founded in 1913 in Atlanta, Georgia, the SIAC is one of the oldest African-American athletic conferences in the country. Officials from Talladega College and Morehouse College were the originators of this conference, and the first meetings were held at Morehouse. The original members included Jackson College, Florida A&M, Talladega, Atlanta University, Morehouse, Clark, Morris Brown, and Fisk.

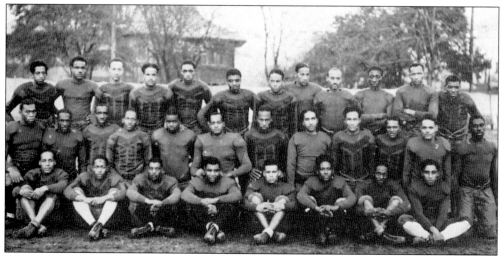

Although the Fisk men provided formidable opposition early in the university's football history, the 1929 gridiron team proved to be one of the most successful. The gold and blue Bulldogs inaugurated the season with a 13-0 victory over the Tigers of Lincoln University in Missouri. Fisk would go on to defeat the Dragons of Lane College, the Maroon Tigers of Morehouse (7-0), Knoxville (26-0), the Crimson Tornado of Talladega (19-0), the Bison of Howard (31-0), Tennessee State (20-0), and the Panthers of Prairie View (20-0). Fisk's only defeat came at the hands of Wilberforce University (7-12) when the Bulldogs of Fisk journeyed to Wilberforce on a cold October 19 for a hard-fought match. Fisk outmatched the "Force" in speed and generalship; however, errors and bad breaks allowed the green and gold of Wilberforce to be victorious.

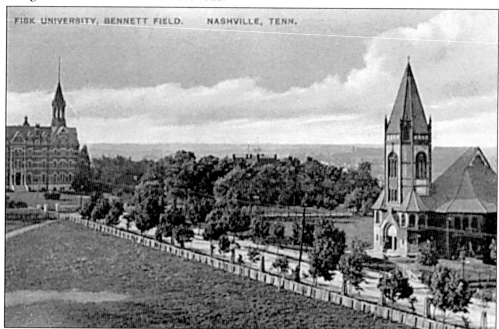

Prior to the construction of Cravath Hall in 1930, the Fisk football team played its games on what was then known as the Bennett Field. Pictured here is a postcard of Bennett. (Courtesy of the Rodney T. Cohen Collection.)

98

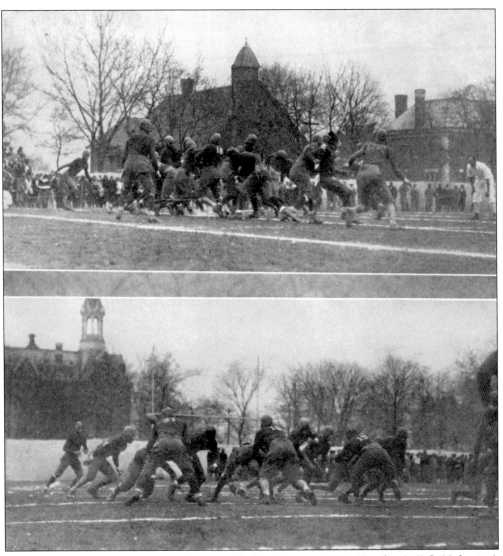

Here is Fisk playing Tennessee State on Turkey Day, c. 1930. The football field for Fisk during that time was located on the plot of land between Cravath Hall and the chapel. The playing area was known as "Bennett Field."

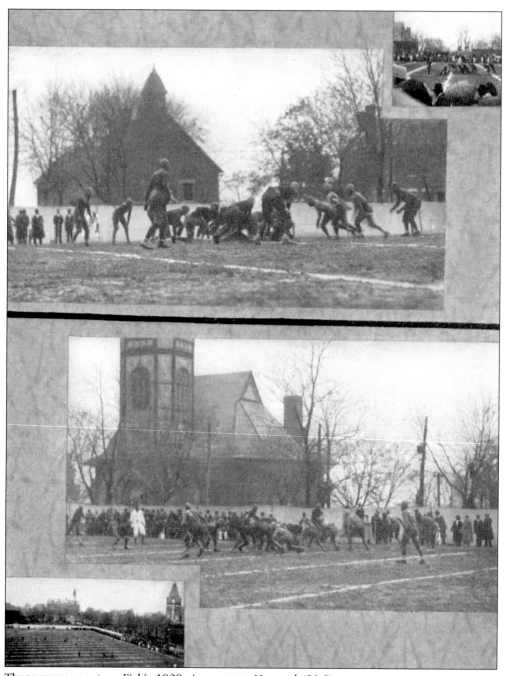

These scenes capture Fisk's 1929 victory over Howard (31-0).

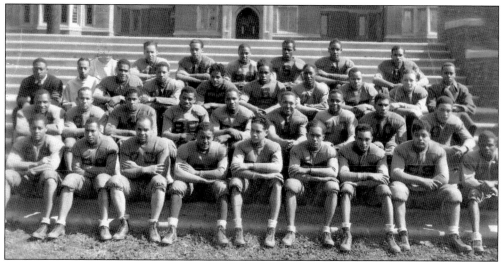

This is the Fisk Bulldogs football team in 1932. During the early 1930s, Fisk placed two players, Booker Pierce and Joseph Wiggins, on the *Pittsburgh Courier*'s Black College All-American Football teams. Other outstanding football greats of note include Tubby Johnson, Charles Wesley, and Booker T. Washington Jr., the son of Tuskegee's Booker T. Washington.

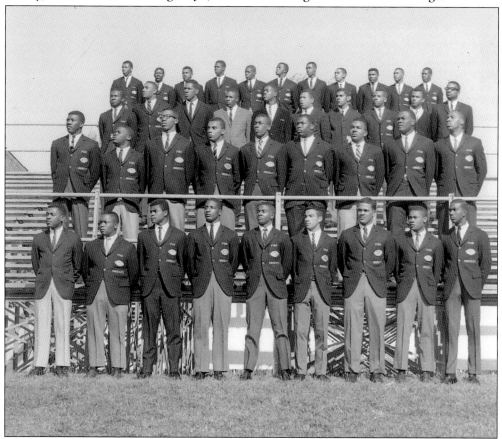

This is a 1960s photograph of the Fisk football team as they pose in their football blazers.

The 1910s and 1920s proved to be the gold and blue's most successful football era. During that period, Fisk bested such teams as Wilberforce, Tuskegee, Howard, Lincoln, and Morehouse to win Southern football championships in 1910, 1912, 1913, 1915, 1919, 1928, and 1929. Pictured here is a 1920s group of Fisk football standouts.

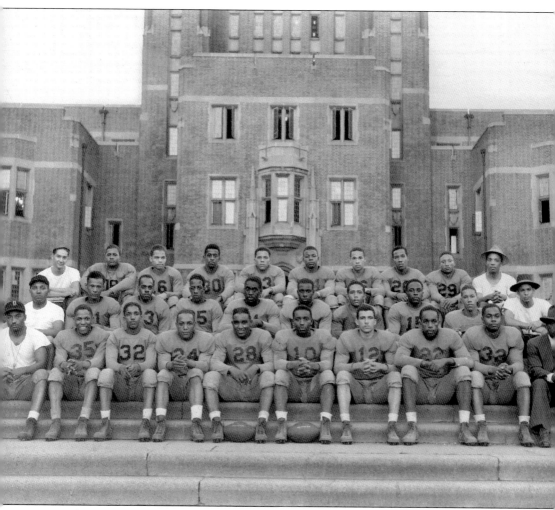

During the 1893 season, the "Sons of Milo" did not allow any opponent to cross their goal line or to score in any manner. That year Fisk played such schools as Meharry Medical College, Roger Williams University in Nashville, and Atlanta Baptist College (later Morehouse). Between 1899 and 1904, Fisk lost only one game (in 1902 against Meharry). Holding true to a "lessons first" policy, Fisk retained a coach for all but one year during its early stages. As a result, Fisk was one of the first schools to use "the Statue of Liberty" play, the "criss cross," or double reverse play, and the "hidden ball" play. Pictured here is a 1941 photograph of the Fisk Bulldogs.

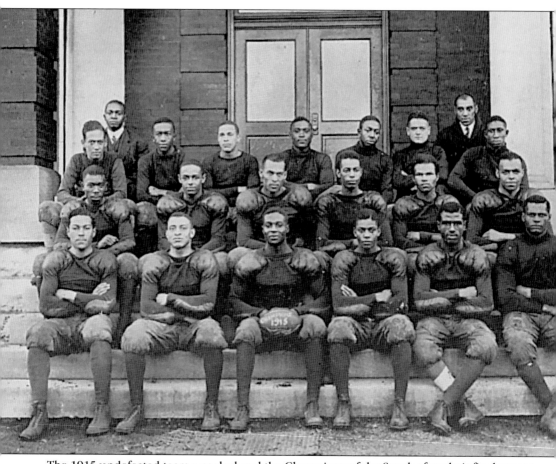

The 1915 undefeated team was declared the Champions of the South after their final season victory, 47-0 over Tuskegee.

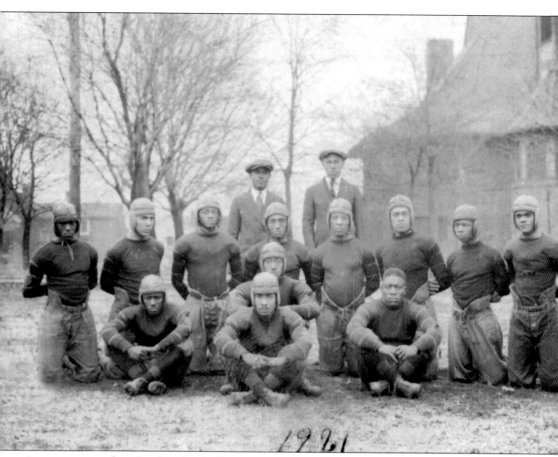

Just one year after the first football contest in 1892 between black colleges—Livingstone College and Biddle Institute—Fisk established its own football team, which was considered by many to be the first of its kind in the Deep South among black colleges. Through the efforts of Charles W. Snyder and W.E.B. DuBois, the idea of playing football at Fisk was introduced. Snyder, who had played high school football in Connecticut, taught the game to Fisk men and served as Fisk's first captain. In the early years, the alumni association and not the university primarily controlled athletics. The early Fisk teams, beginning in 1893, bore the nickname "Sons of Milo" after Fisk's first president, Erastus Milo Cravath. Later, the Fisk teams would be known as the "Bulldogs." Pictured is the Fisk team in 1921.

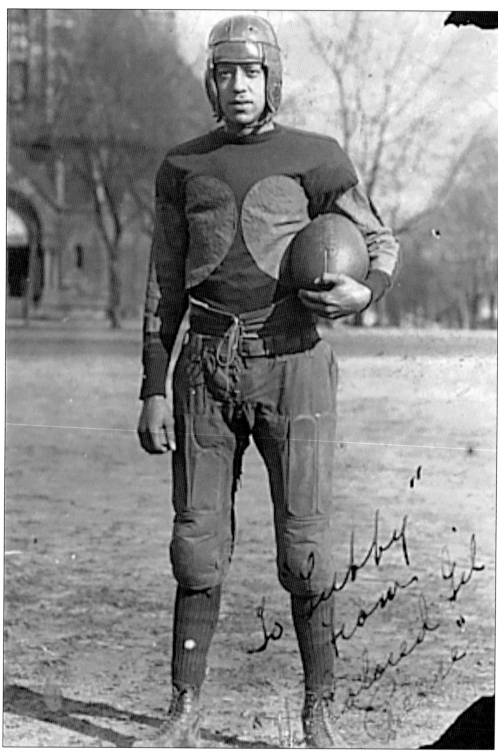

This *c.* 1920s football photograph was given to Coach Henderson A. "Tubby" Johnson and was signed "To Tubby from the Colored Gil Reese."

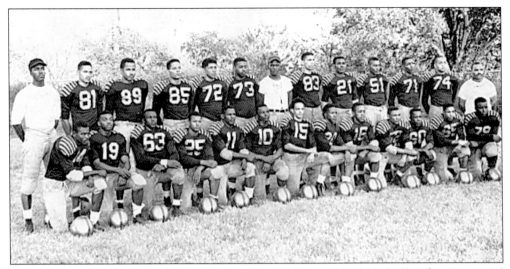

On October 30, 1954, the Fisk football squad pictured here played Nashville's first interracial football game against Taylor University of Upland, Indiana.

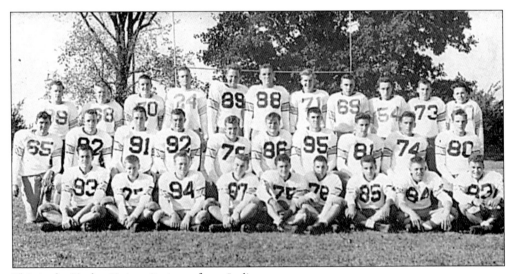

This is the Taylor University team from Indiana.

FOOTBALL SCHEDULE 1954

October	2	Tuskegee	Home
"	9	Alabama A & M	Normal
"	16	Dillard	New Orleans
"	23	Howard	Washington
"	30	Taylor	Homecoming
November	6	Lane	Home
"	13	Clark	Home
"	20	Morehouse	Atlanta

The 1954 Fisk University football season was monumental in that Fisk became the first school in Nashville to host an integrated football match.

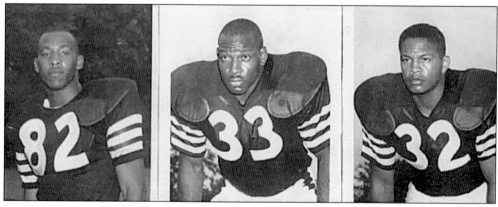

In 1964, LaMarr Richardson (left), Ollice Holden (center), and James Martin (right) were drafted into the National Football League. The Baltimore Colts drafted Richardson and Martin; the St. Louis Cardinals drafted Holden.

Prior to becoming the Van Vechten Gallery in 1949, this structure, built in 1888, served as the nation's first gymnasium and mechanical laboratory on a historically black college campus. The impetus for the project began with W.E.B. DuBois and three other classmates serving on a committee whose purpose was to raise money and create a fund to aid in the building of the gym. According to DuBois, the students raised $700 toward the erection of the gym.

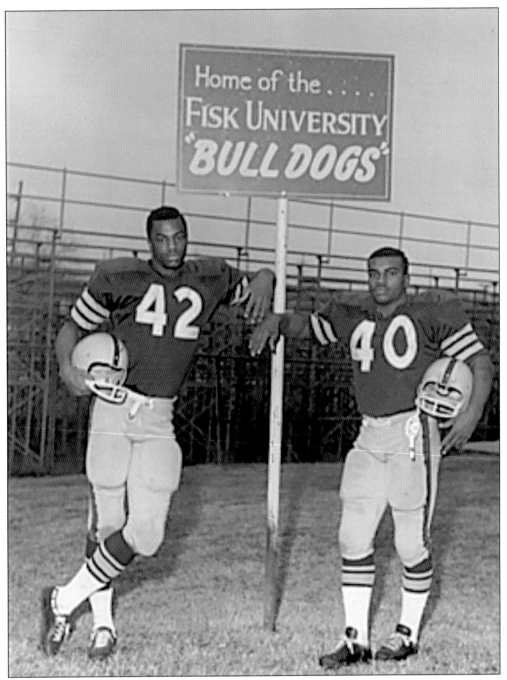

Two Fisk football players are pictured on the Pearl High football field staking their ground and proclaiming the field "Home of the . . . Fisk University 'Bulldogs.' " During the 1960s, many of the games were played at the near-by "all-black" Pearl High.

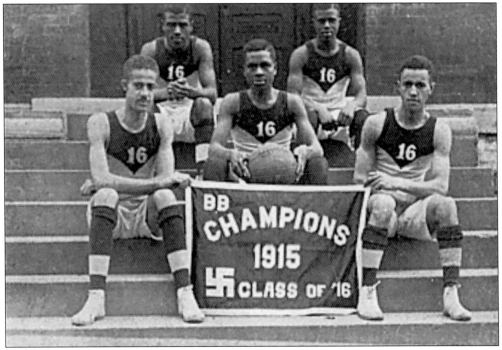

Intramurals were a big part of early athletic life at Fisk. Pictured here is the senior basketball team in 1916.

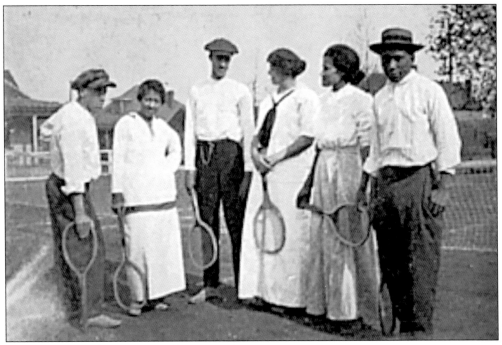

This is a group of Fisk tennis players, c. 1917.

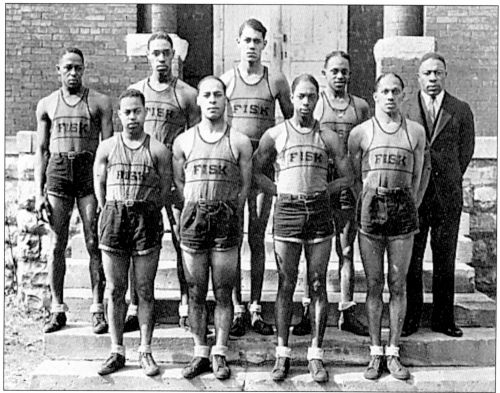

Coach Tubby Johnson (second row, fifth from left) appears in this photograph of the 1929–1930 Fisk basketball team. During that year, the Fisk "basketeers" bested such teams as Tuskegee, Wilberforce, Johnson C. Smith, and Louisville Municipal College.

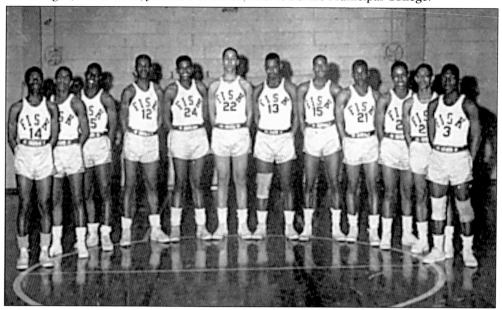

In the spring of 1953, the Fisk basketball squad played Morehouse College in Chicago in a game that was jointly sponsored by the Fisk and Morehouse alumni clubs of Chicago.

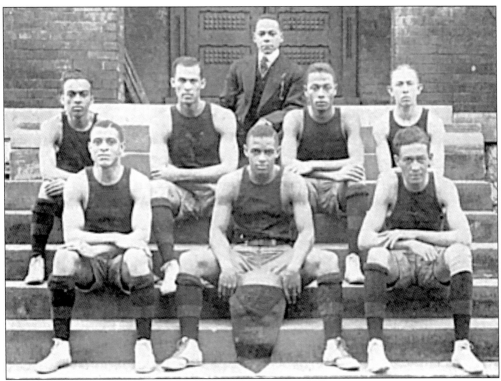

In addition to the stimulation of the mind through athletics, the development of the body was a considerable priority at Fisk. As a result, significant intramural programs were developed to include the general Fisk population, including sports teams from fraternities and class years. Pictured here is the 1916 freshman basketball team.

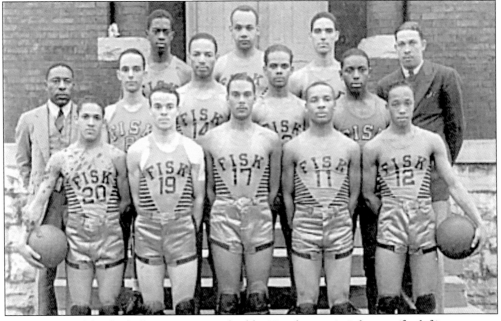

This 1930s Fisk basketball team was coached by Henderson A. Johnson (far left).

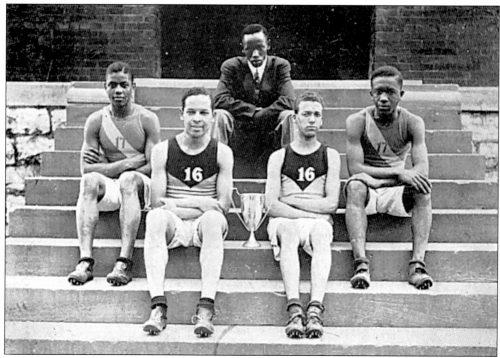

This is the 1915 relay team of Fisk University.

This is a 1960s photograph of the Fisk track team.

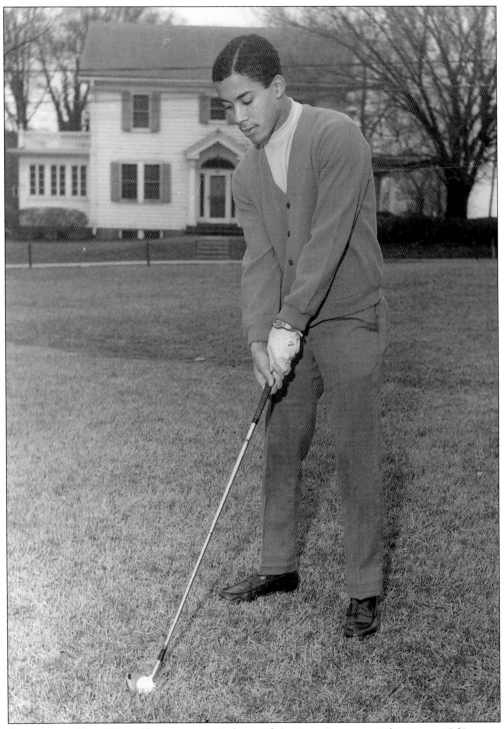

A member of the Fisk golf team poses in front of the Arna Bontempts house, *c.* 1960s.

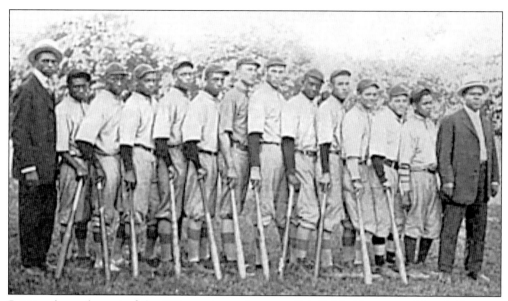

During the early part of the 20th century, classes at Fisk fielded intramural baseball teams and played each other competitively. During 1916, the teams played two games every Saturday for six weeks and held a championship at the end that pitted the freshman against the sophomores and the juniors against the seniors. Pictured here is an intramural baseball team during the 1915–1916 academic year.

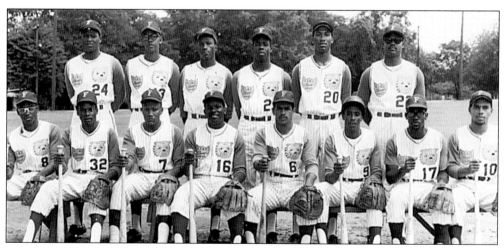

This is the 1969 edition of the Fisk baseball team. They were the defending champions, having won the SIAC conference in 1967 and 1968. In 1968 they played such teams as Vanderbilt, Morris Brown, Alabama State, and Tuskegee.

Seven

FISKITES

. . . her sons are steadfast, her daughters true . . .

—The Gold and Blue

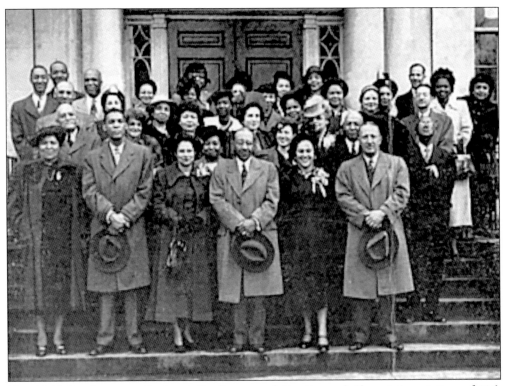

The 1949 Southeastern Regional Conference of the General Alumni Association of Fisk University was held on the campuses of Clark College and Atlanta University. In the front row is President Charles S. Johnson (center) of Fisk.

FISK NEWS

"Her Sons and Daughters Are Ever on the Altar"

VOLUME XXIV JUNE, 1951 NUMBER 4

$30,000 GOAL

To Repair Jubilee Hall

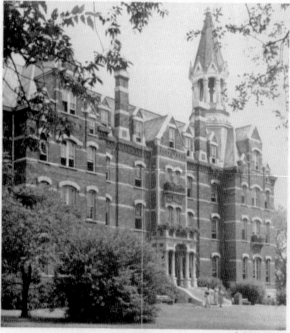

JUBILEE HALL

—A. Glenn Hanson

Where e'er we be we shall still love thee . . .

This Is *Your* Heritage, *Keep* It Firm
Remember, It's not what you give, But *that* you give!

This 1951 edition of *Fisk News* reported on the $30,000 campaign for the repair of Jubilee Hall. Built in 1875, Jubilee Hall continues to stand as the heroic symbol of the fund-raising efforts of the original Jubilee Singers. Jubilee Hall was the first permanent building constructed at Fisk and the first permanent building constructed in America for the exclusive purpose of providing higher education to African-American students.

YOUR ALMA MATER

First you will back
your Alma Mater by
giving to the Alumni Fund.
All contributions are tax
deductible.

If you remember your days at the
University as the best of your life
help make them the best for some
one else.

Sure, Alumni Fund monies go to do
the most for your University
In the spot where you select it
to be used.

Keep October 6, 1951, Jubilee
Day, in mind. Have your
contribution in to the Alumni
Office by that time.

UNIVERSITY

Here is a typical alumni "reminder" and "plea" card, encouraging Fiskites to participate in the affairs of their alma mater.

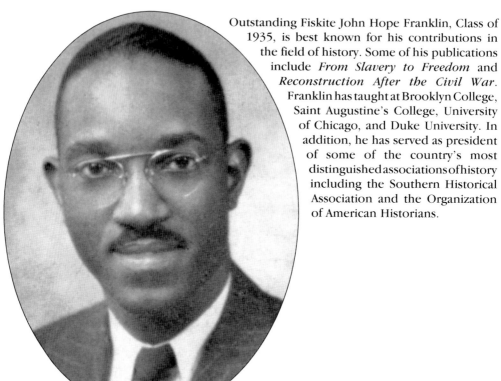

Outstanding Fiskite John Hope Franklin, Class of 1935, is best known for his contributions in the field of history. Some of his publications include *From Slavery to Freedom* and *Reconstruction After the Civil War*. Franklin has taught at Brooklyn College, Saint Augustine's College, University of Chicago, and Duke University. In addition, he has served as president of some of the country's most distinguished associations of history including the Southern Historical Association and the Organization of American Historians.

A 1911 graduate of Fisk University, Dr. Charles Harris Wesley distinguished himself as an outstanding educator and historian. Entering the Fisk Preparatory School at age 14, he participated on the Fisk debating team, toured with the Jubilee Singers, ran track, excelled in baseball and basketball, and was the star quarterback of the football team, all winning him the varsity "F." Wesley received a degree with honors in classics, which earned him the Phi Beta Kappa key retroactively in 1953. At age 19, he entered Yale's graduate school on a tuition fellowship. Before leaving Yale at 21 with a master's degree in history and economics, he was initiated into the Zeta Chapter of Alpha Phi Alpha (Alpha did not arrive at Fisk until 1927) along with 12 other men. Wesley later wrote the history of Alpha and wrote on C.C. Poindexter, who was known as the "precursor" of Alpha and was Wesley's botany professor at Fisk. He would also go on to serve as the president of Alpha Phi Alpha, Wilberforce University, and Central State University.

Here, the General Alumni Association pays tribute to Miss Fisk at a halftime celebration.

The Fisk Club of New York gathers for a Christmas party in December 1953.

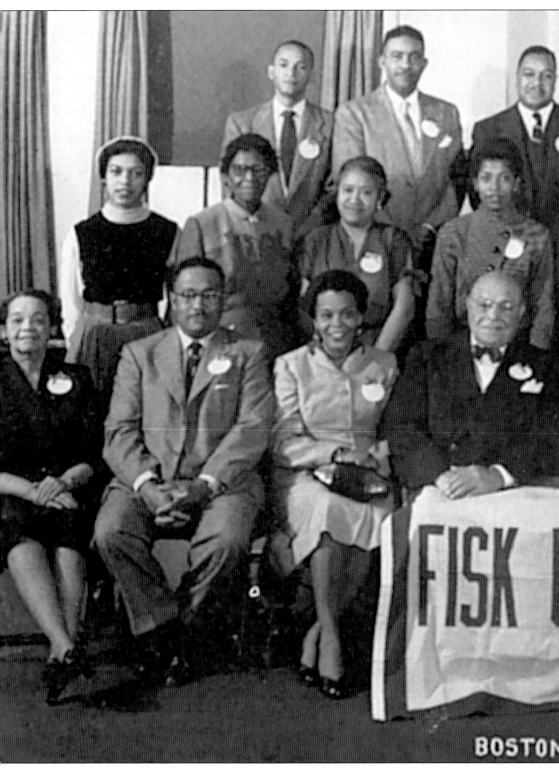

This November 1953 photograph shows the Fisk University Eastern Regional Alumni

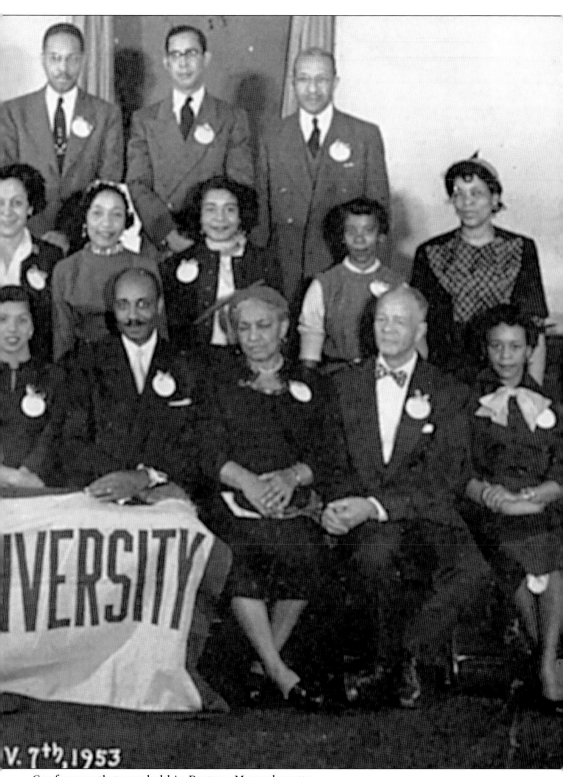

V. 7th, 1953

Conference that was held in Boston, Massachusetts.

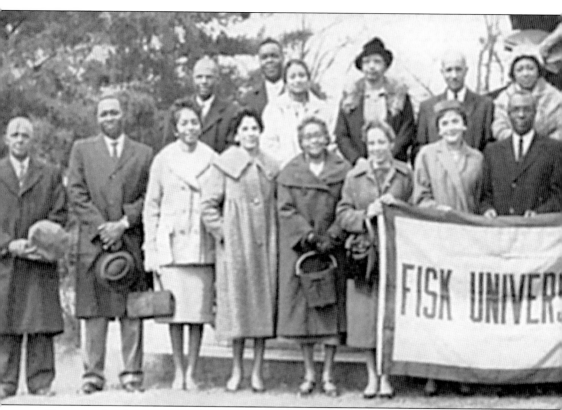

The growth of an organized alumni association at Fisk dates back as far as 1880, when some Fisk graduates met in the parlor of Jubilee Hall to develop and organize an alumni association. J.D. Burrus served as chairman of that group and Dr. J.E. Porter acted as the secretary. At this meeting, the alumni read and adopted their constitution. Since then, many attempts have been made to support the efforts of the university through alumni contributions in the form of scholarships and endowments. As a result of such involvement, Fisk established its first full-time alumni secretary who was hired as an administrator of the university. Fisk was the second black college, following Howard, to establish such a position. This 1960 photograph demonstrates the consistent alumni involvement exhibited by Fiskites. Posing above in front of the famed Booker T. Washington statue are the members of the Southeastern Regional Conference of the General Alumni Association that was held on the campus of Tuskegee Institute in 1960.

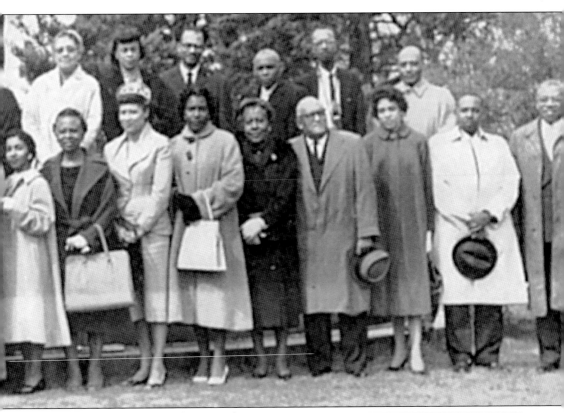

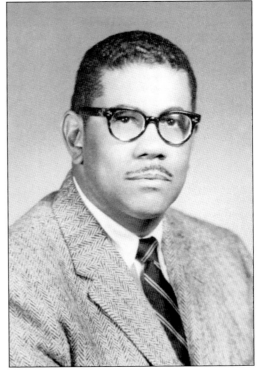

James Raymond Lawson (right) served as president of Fisk University from 1968 to 1975. He was a member of the Class of 1935 and the first Fiskite to serve as president of Fisk.

A native of Chattanooga, Roland Hayes ventured to Fisk and was hailed as one of the most notable singers to walk the halls of the university. According to Richardson, "His rise to fame is almost as romantic as that of the Jubilee Singers." Having very little means as a child, Hayes worked odd jobs and sang regularly in church choirs. After hearing him sing, music instructor Arthur Calhoun influenced Hayes to enhance his skills and take formal lessons. Hayes's ability soon caught the attention of some Chattanooga sympathizers who then assisted Hayes in raising money for higher education. With money in hand, Hayes was headed to Oberlin in Ohio when Fisk suddenly called. Answering that call, Hayes continued his singing career at Fisk for four years while continuing to work odd jobs to pay for tuition and other expenses. It was not until 1917 that Hayes would gain widespread recognition at a concert given in Boston. In 1930 Hayes returned to Fisk, and in the tradition of the Jubilee Singers, performed in a benefit concert for the university. In 1932 and in recognition of Hayes's accomplishments, Fisk broke rank with its long tradition of not granting honorary degrees and granted Hayes its first, a doctorate of music.

Pictured here is a younger Roland Hayes.

BIBLIOGRAPHY

Brawley, J.P. *The Clark College Legacy*. Princeton: University Press, 1977.

Cohen, R.T. *The Black Colleges of Atlanta*. Charleston, SC: Arcadia, 2000.

Collins, L.M. *One Hundred Years of Fisk University Presidents, 1875–1975*. Nashville: Hemphill Creative Printing, Inc., 1989.

Lewis, D.L. *When Harlem Was In Vogue*. New York: Oxford University Press, 1989.

Locke, A. *The New Negro*. New York: Albert and Charles Boni, 1925.

Richardson, J. *A History of Fisk University, 1865–1946*. Alabama: The University Press, 1980.

Wesley, C.H. *The History of Alpha Phi Alpha: A Development in College Life*. Washington, DC: The Foundation Publishers, 1948.

Additional Sources

Atlanta University Bulletin. Series III. No. 72. Dec. 1950.

The Sphinx. Vol. 68. No. 1. P. 14-28.

Silver Jubilee, 1913–1938 SIAC 1940.

Fisk University News, Vol. IX. No. 2. Oct. 1918.

Fisk University News, Vol. XXVI. No. 1. Nov. 1952.

Fisk University News, Vol. XXVI. No. 3. Mar. 1953.

Fisk University Bulletin, Vol. 5. No. 1. June 1930.